W9-CHC-348

ANISH KAPOOR

PAST PRESENT FUTURE

ANISH KAPOOR

INSTITUTE OF CONTEMPORARY ART / BOSTON

ISH
POOR
PRESENT
TURE

INSTITUTE OF CONTEMPORARY ART / BOSTON

PAST PRESENT FUTURE

Anish Kapoor: Past, Present, Future

Exhibition dates at the Institute of
Contemporary Art, Boston
30 May–7 September 2008

© 2008 The Institute of
Contemporary Art, Boston
100 Northern Avenue
Boston, MA 02210
www.icaboston.org

This publication is made possible in
part by the support of the Carl and
Ruth Shapiro Family Foundation.
Additional support was provided by
the Nathaniel Saltonstall Arts Fund.

MIT Press books may be purchased
at special quantity discounts for
business or sales promotional use.
For information, please email
special_sales@mitpress.mit.edu or
write to Special Sales Department,
The MIT Press, 55 Hayward Street,
Cambridge, MA 02142.

This book was set in Freight Big and
Freight Text by Joshua Darden and
Grotesque MT Light, and was printed
and bound at GZD, Germany.

Book design: Omnivore
Julie Cho, Alice Chung

Cover and endpapers: *Cloud Gate*,
2004 (detail)

**Library of Congress Cataloging-
in-Publication Data**

Kapoor, Anish, 1954–
 Anish Kapoor : past, present, future /
edited by Nicholas Baume; contribu-
tions by Nicholas Baume...[et al.] and
selected pages from Anish Kapoor's
notebooks.
 p. cm.
 Published in association with an
exhibition to be held at the Institute
of Contemporary Art in Boston.
 Includes bibliographical
 references.
 ISBN 978-0-262-02659-8
 (hardcover : alk. paper)
1. Kapoor, Anish, 1954—Exhibitions.
I. Baume, Nicholas. II. Institute of
Contemporary Art (Boston, Mass.)
III. Title.
 NB1010.K28A4 2008
 730.92—dc22

 2008005119
10 9 8 7 6 5 4 3 2

INSTITUTE OF CONTEMPORARY ART / BOSTON

edited by Nicholas Baume

contributions by Nicholas Baume,
Mary Jane Jacob, Anish Kapoor,
Partha Mitter, and selected pages
from Anish Kapoor's notebooks

INSTITUTE OF CONTEMPORARY ART / BOSTON

The Institute of Contemporary Art/Boston

The MIT Press
Cambridge, Massachusetts
London, England

PAST PRESENT FUTURE

INSTITUTE OF CONTEMPORARY ART / BOSTON

INSTITUTE OF CONTEMPORARY ART / BOSTON

PAST PRESENT FUTURE

FOREWORD

By so many measures, the world has grown smaller and flatter; information moves faster and more clearly, communications are louder and more insistent. In this overloaded universe, the art of Anish Kapoor is a necessary counterpoint. His sinuous curves, saturated pigments, inverted images, and mirrored surfaces exercise a seductive subtlety. Kapoor's art invites us to embark on an artistic experience that is sensual, slow, and, like a powerful landscape, able to awaken and satisfy our curiosity and senses as well as our longing for meaning and profundity.

The ICA is proud to present *Anish Kapoor: Past, Present, Future*. It has been fifteen years since American audiences had occasion to experience a survey of Kapoor's work, and this is the first ever mounted on the East Coast. It is also a homecoming of sorts, since the artist's first solo museum exhibition in the United States, curated by David Joselit, was mounted at the ICA in 1985 as part of our groundbreaking *Currents* series. Now at mid-career, Kapoor is one of the most significant artists at work today. His art has delighted viewers worldwide, including many thousands of visitors to Rockefeller Center in New York City and Millennium Park in Chicago.

Anish Kapoor: Past, Present, Future is the realization of several years of collaboration between the artist and ICA chief curator Nicholas Baume, who worked closely with the artist to shape the exhibition's visual and conceptual flow. Nicholas demonstrated tremendous leadership and the tenacity needed to successfully deliver this exhibition and catalogue, and we are very grateful for this contribution to the field. He was assisted by a talented curatorial and installation team.

To bring this project to fruition, we sought the support of several lenders and galleries whose generosity and assistance made the project possible. Our thanks go to Gladstone Gallery, New York; LeWitt Collection, Chester, Connecticut; Lisson Gallery, London; Collection Prada, Milan; and Regen Projects, Los Angeles. We are also grateful to the Carl and Ruth Shapiro Family Foundation and the Nathaniel Saltonstall Arts Fund for their support of this publication.

Our deepest thanks go, however, to the artist. Anish Kapoor's art was already a presence in the ICA long before his exhibition opened. We all happily imagined his sculptures in the light and space of our new galleries, and we are immensely grateful to Anish for his time, his generosity, and his art. While a penetrating sense of mystery pervades his work, it is no mystery at all that it has become an iconic art for our time.

JILL MEDVEDOW, *director*

ACKNOWLEDGMENTS

When Jill Medvedow first showed me Diller Scofidio + Renfro's plans for the new ICA galleries, I was struck by their abundant daylight and open, flexible space. These galleries would be ideal for art that flourishes in the diffused radiance and subtle depth of natural light. The open floor plan would comfortably accommodate works of scale and ambition. Anish Kapoor came to mind immediately. I imagined a survey of his sculptures not only responding to the building's attributes, but also amplifying its character in their perceptual dialogue between form and space. Steeped in both distant cultural memory and recent artistic practice, Kapoor's art is at once unmistakably contemporary and evocative of geological time. From formless wax extrusions to implosions of surface energy, his work generates impulses as libidinal as they are ethereal.

Anish Kapoor is among the busiest artists I know. At any one time he is planning exhibitions for museums and galleries all over the globe, working on major public commissions with architects and engineers, creating works on paper or jotting down ideas in his voluminous notebooks, and above all keeping his perpetually active South London studio humming with the development and production of new works. I am very grateful that in the midst of all this Anish agreed to undertake this exhibition, and found time to talk with me about his work over several visits to his studio. The resulting conversation published here reveals the arc of Kapoor's thinking and creative process over the past 30 years.

In his essay "History, Memory, and Anish Kapoor," Partha Mitter, the eminent scholar of modernism and Indian art, brings the formidable range of his art historical and interpretive insight to bear on the manifold resonances of Kapoor's art. Distinguished curator and author Mary Jane Jacob, who has long followed the artist's career, has contributed "Being with *Cloud Gate*," a meditation on the transformative power of Kapoor's iconic public sculpture in Chicago's Millennium Park. Over the years, Kapoor has filled many notebooks with his sketches and thoughts on art. A selection of these pages is published here for the first time. They literally punctuate the book from beginning to end with the "voice" of the artist.

This monograph builds on the previous work of many curators and scholars. My memorable introduction as a student to Kapoor's art came in 1985 when Bill Wright and Tony Bond mounted *The British Show* at the Art Gallery of New South Wales in Sydney. More recently, I have learned much from the perceptive writings of Homi Bhabha, Germano Celant, Donna De

Salvo, and David Joselit. Professor Bhabha, Director of the Humanities Center at Harvard, has also been a valued advisor; I am grateful for both his counsel and collegial support. I am thankful to my colleague Woodman Taylor in the department of South Asian and Islamic Art at the Museum of Fine Arts, Boston, for generously sharing his expertise. Roger L. Conover, Executive Editor, and his team at the MIT Press have brought to this project their customary professionalism and unflagging enthusiasm. Matthew Abbate has improved all of it with his punctilious and thoughtful copyediting. This handsome book was designed by Julie Cho and Alice Chung of Omnivore. Their sensitive response to the ideas and forms in Kapoor's work is reflected in its inventive design.

Nicholas Logsdail supported the idea of this exhibition from the start; his encouragement and advocacy have been invaluable. I also thank his colleagues at Lisson Gallery in London, including Heidi Grivas, Karolin Kober, and Justyna Niewiara, who facilitated the exhibition in countless ways. Anish's representatives in the United States, Barbara Gladstone in New York and Shaun Caley Regen in Los Angeles, have also been instrumental supporters all along. Their teams, including Gladstone Gallery Associate Director Miciah Hussey and Regen Projects Director Jennifer Loh, have given enormous help. To these and our other generous lenders I echo Jill Medvedow's warm appreciation. The exhibition could not have been realized without their trust, and I am deeply grateful to Carol and Sol LeWitt (Sol remains with us in so many ways), and to Janet Passehl of the LeWitt Collection; to Miuccia Prada and Patrizio Bertelli, and to Francesca Cattoi of the Collection Prada.

Museum exhibitions and publications are the result of teamwork, and the ICA is fortunate to have a talented staff of uncommon dedication. It has been an enormous pleasure to work closely on every aspect of the exhibition with Curatorial Assistant Bridget Hanson. Bridget's sharp eye, mastery of detail, and unfailing good humor contributed vitally to our success. Registrar Janet Moore's love of Kapoor's work shone through in her astute attention to the very complex tasks of packing, shipping, insuring, and touring his large and often fragile objects around the world. Chief Preparator Tim Obetz has taken on what must be the most technically ambitious exhibition ever mounted at the ICA with his customary sangfroid and determination. Assistant Curator Jen Mergel offered insightful comments on my catalogue essay, and Senior Registrar Nora Donnelly kept a watchful eye on the budget, insurance, and countless other vital aspects. Beyond the curatorial department, I am indebted to many colleagues for their imaginative work. They include Paul Bessire, Deputy Director for External Relations; Carrie Fitzsimmons, Director

of Administration, Planning, and Stewardship; David Henry, Director of Programs; Michael Taubenberger, Director of Finance and Operations; Donna Desrochers, Director of Marketing and Communications; Brigham Fay, Communications Manager, Creative Services and the Web; José Nieto, Senior Graphic Designer; Colette Randall, Communications Manager, Media Relations and Marketing; Emma Fernandez, Education and Interpretation Specialist; Lizzi Ross, Adult Program Manager; and Branka Bogdanov, Director of Film and Media, whose fascinating film on Kapoor affords a unique portrait of the artist.

We have relied heavily on the collaboration of Anish Kapoor's terrific studio team, and owe a great debt of thanks to Melanie Ahmed, Peter Berwick, Clare Chapman, and Zoë Sullivan; and to expert installers Jeff Dyson and Christophe Taudon. They have responded to our innumerable queries and requests with alacrity and grace. Above all, it has been a thrilling experience to work with Anish himself. I have delighted in the opportunity to see sculptures take shape in his studio over many months, and to engage him about the central ideas of his art. He has submitted to the sometimes intrusive demands of exhibition making with patience and generosity, and has applied the powerful force of his intelligence and imagination to its every aspect.

NICHOLAS BAUME, *chief curator*

FLOA
THE
PECUL

NICHOLAS BAUME

TING IN
MOST
IAR WAY

NICHOLAS BAUME

My Body Your Body,
1993

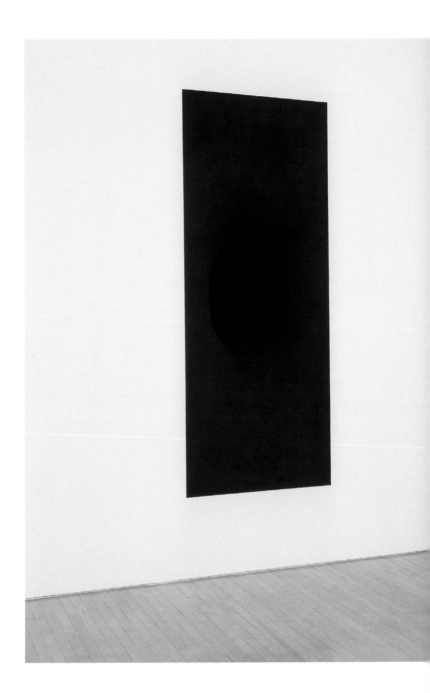

All great masters, in their work, seek that
profound void within color and outside time.

—Orhan Pamuk, *My Name Is Red* [1]

Those of us raised on the bracing diet of pop, minimal, and conceptual art have long been suspicious of artistic notions of individualism and transcendence, preferring that art's relation to metaphysical conceits be one of demystification. At the same time, consumer society has become only more enthralled by the production and consumption of mythic beliefs, values, and objects. Offering a different creative model, Anish Kapoor's work has neither resurrected a romantic notion of transcendent individualism nor joined in the celebration of pop culture. Rather, he has produced abstract art at the most sophisticated level of formal invention that also unabashedly aspires to the mythic; that invites speculation about origins and finality, the corporeal and the infinite. His work achieves this through a combination of cultural meaning, conceptualist method, and material innovation brought into a dialogue as complexly layered as it is creatively efficient.

Over a career spanning thirty years Kapoor has produced an extraordinarily varied body of work. Raw pigment, chalk, earth, polystyrene, fiberglass, stone of many kinds, gourds, concrete, aluminum, stainless steel, bronze, felt, acrylic, polyvinyl chloride, Vaseline, and wax are just some of his materials. Several are the stuff of classical sculpture, others newer to art, the products of recent industrial technologies. This diversity notwithstanding, it is clear that the whole of Kapoor's art coheres around a set of fundamental, related concerns.

Kapoor's first solo museum exhibition in the United States was mounted at the ICA Boston in 1985.[2] That exhibition included several works from the *1000 Names* series, which first earned him critical attention in Europe.[3] Their evocative forms and bold use of intensely colored raw pigment had come as a striking departure from both the formalist school of British sculpture and the austere abstractions of American minimalism. As ICA curator David Joselit wrote, "The optical intensity of pure primary color and its extension onto the floor serves to dissolve volume into a kind of hallucinatory color spot."[4] The pigment pieces signaled the hybrid cultural identity that has shaped Kapoor as an artist informed by both a British art education and his Indian heritage. In retrospect, we can also see in this body of work the generative principles that have formed the basis of his art ever since. The following discussion seeks to characterize those principles.

1— Orhan Pamuk, *My Name Is Red* (New York: Vintage, 2002), p. 76.
2—Curated by David Joselit, *Anish Kapoor* was one in an ongoing exhibition series titled *Currents*.
3—The series of works collectively titled *1000 Names* was made between 1979 and 1982. Some works in the series are single forms, others are specific groupings of several objects. All of them share the same title while dates of realization range from 1979 to 1982.
4— David Joselit, *Currents* (brochure), Institute of Contemporary Art, Boston, number 39, April 1985, n.p.

UNCERTAIN OBJECTS

The world is an illusion, and art is the presentation of the illusion of the world.

—Paul Virilio, "The Aesthetics of Disappearance" [5]

David Joselit's 1985 terms "dissolve" and "hallucinatory" could be used in relation to almost any Kapoor object made then or since; in different ways, their physical status is always ambiguous. There are several kinds of uncertainty about the pigment pieces. First is the question of whether or not they are made entirely of pigment, and how slender their grasp on objecthood must be if comprised of so evanescent a substance. Then there is the dematerializing retinal blur of pure color that makes edges ambiguous and details fugitive. Forms appear to emerge as if from below the floor or beyond the wall, implying that what we see may be only part

1000 Names,
1979-80

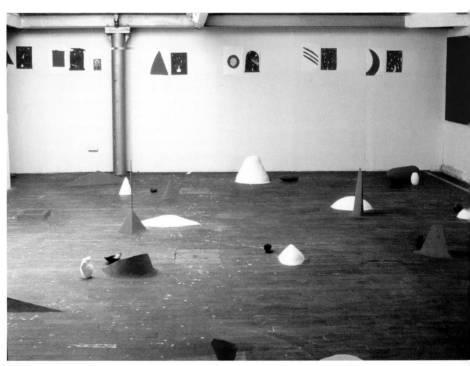

of something much larger. This is not a game of cat and mouse; there is no uncertainty that we are in the presence of three-dimensional forms. Yet like so many works that follow, the pigment pieces draw us in because the way they behave is not "normal." Kapoor's objects are active; they always suggest a process of becoming, both experientially and imaginatively. What at first we thought was solid stone contains a void, what seemed to be a flat plane morphs into a protrusion, a mirrored three-dimensional

5— Paul Virilio, "The Aesthetics of Disappearance," in *The Paul Virilio Reader,* ed. Steve Redhead (New York: Columbia University Press, 2004), p. 76.

form opens an unfamiliar window into unbounded space. Consider *Marsupial*, 2006: as we move from one side of this wall-touching sculpture to the other, a shallow elliptical cavity transforms into a tensile, fully formed pouch. The artist instills a kind of "cognitive dissonance" into his objects as our conflicting perceptions compete for primacy. Subjective experience is always complicated in the encounter with Kapoor's work; as we question the object, we question ourselves.

SPACE BEYOND
Who knows what exists that we haven't yet seen?
—Lisa Randall, *Warped Passages*[6]

Contradicting the minimalist dictum that "what you see is what you see," Anish Kapoor's art mounts an assault on perceptual empiricism. His work

Marsupial, 2006

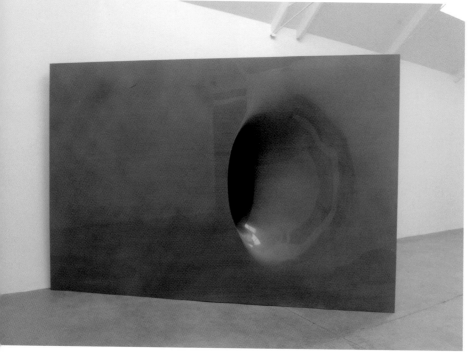

has always been about what is not seen, what is implied, or what is seen and yet contradicted by our everyday knowledge of the world. The pigment pieces take on the space of the white cube by rendering it metaphorical; they dissolve its physical limits and infer an imaginary space beyond. Subsequent bodies of work make that "space beyond" literal, or deploy materials to create complex and counterintuitive spatial effects. *My Body Your Body*, 1993, appears at first to be a flat plane on the wall until we realize that

6—Lisa Randall, *Warped Passages: Unraveling the Mysteries of the Universe's Hidden Dimensions* (New York: HarperCollins, 2005), p. 21.

the space of the work is beyond the wall, creating an intensely blue "void" whose dimension and extension evade certain observation. In *Iris*, 1998, a similar perceptual effect suggests a flat circular plane; as we approach, it reveals itself to be a concave, highly polished stainless steel form set into the wall that beckons us toward its hallucinatory virtual space. Perhaps Kapoor's most ambitious exploration of the complex dynamics of mirrored form is *Cloud Gate*, 2004, commissioned for Chicago's Millennium Park. Its form is closely related to the biomorphic shape of the earlier white sculpture *Untitled*, 1998, rotated 90 degrees over its orthogonal opening, which in Chicago has become seamlessly curved. In *Cloud*

Cloud Gate, 2004

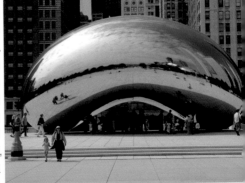

Gate we physically enter the realm of the object. The convex shell of its arched form rises to admit us into the concave space of its underbelly. Looking upward into its "navel" is like gazing into a warped dimension of fluid space. All that was solid has morphed into liquid in a disorienting yet mesmerizing multiplication and intensification of vision. In effect, all of Kapoor's work undertakes a deconstruction of empirical space as it explores the manifold possibilities of abstract space.

Untitled, 1998

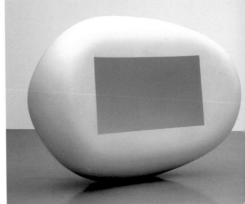

SKIN AS STRUCTURE
Instead of projection inward in depth or outward in space,
there is an implosion of space within the surface itself.
—David Joselit, "Surface Vision" [7]

The pigment pieces do away with any notion that the structural conditions of an object should be legible in its external form. Rather, Kapoor became interested in how an object's surface (or what appears to be its surface) determines the way it is read regardless or even in spite of the way it is put together. Thus it is the optical character of pure pigment and its extension around the object's perimeter that determine the way it is perceived. For

Kapoor the pigment forms a skin, a term that suggests a more organic presence than "surface." Skin changes, it breathes, it is seamless and elastic. Kapoor's most candidly anthropomorphic work, *When I am Pregnant*, 1992, turns the surface of a white painted wall into the skin of a rounded bulge. *Descent into Limbo*, 1992, creates a perceptual skin that appears to be stretched tight across a circular plane until it vanishes with the recognition that the dark field is a void. If the optical intensity of pigment can be said to dissolve volume, the mirror-finished object both dissolves and activates it. The physically shallow volume of the mirror-polished dish *Brandy Wine*, 2007, becomes a dynamic, indeterminate space as we bear witness to the apparitions before its tremulous skin. Skin literally becomes structure in *Marsyas*, a 2002 installation at Tate Modern where a colossal PVC membrane was stretched between three rings running the length of the Turbine Hall. Not only was its muscular form produced by the PVC membrane; its yawning orifices lent further bodily resonance to the metaphor of skin. In Kapoor's hands, the conventional dichotomy between surface and depth is collapsed in a new dynamic of physically and visually extended skin.

When I am Pregnant, 1992

7— David Joselit, "Surface Vision," in *Super Vision*, ed. Nicholas Baume (Boston: Institute of Contemporary Art; Cambridge: MIT Press, 2006), p. 173.

To Reflect an Intimate Part of the Red, 1981

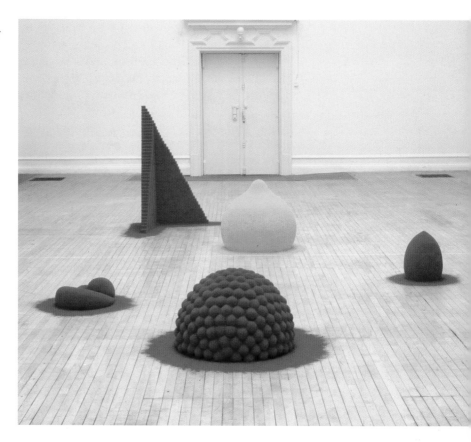

Marsyas, 2002

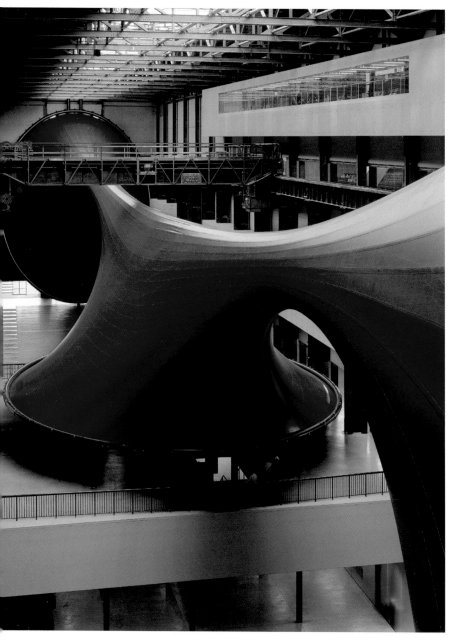

ALLUSIVE ABSTRACTION

There is thus an incessant multiplication of the inexhaustible One and unification of the indefinitely Many.

—Ananda K. Coomaraswamy, "The Hindu Tradition: The Myth"[8]

Vishnu, the all-powerful Hindu deity, has 1000 names, each to express a different attribute. With no single material nature, he may manifest in any form. Invoking this mythic representation of simultaneous unity and multiplicity, Kapoor gave a single title to an entire body of work. From this early moment of the *1000 Names* series, it is clear that Kapoor's art, while resolutely abstract, would invite rather than resist the widest range of associations. Moreover, those associations would be grounded in the physical world, in its most basic bodily and constructed forms, yet would also connect to spiritual questions of origin and belief. The penetrating red cone of *1000 Names*, 1979–80, might read as phallic, but is also reminiscent

Minaret, Great Mosque, Samarra, Iraq

of a spiraling minaret, like that of the Great Mosque of Samarra in Iraq. The forms of *To Reflect an Intimate Part of the Red*, 1981, allude to stairways and domes, but also to seeds and breasts. His work abounds in mysterious monochromatic blues, intense yellows, and immaterial whites. But it is red that has played the most central role in the artist's iconography, exploited for its visceral strength, formal possibilities, and cultural resonances. In Orhan Pamuk's novel *My Name Is Red*, the eponymous color is personified as a character who proclaims, "Color is the touch of the eye, music to the deaf, a word out of the darkness…Life begins with and returns to me."[9]

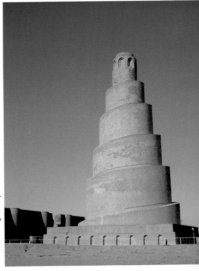

For Kapoor, a measure of artistic success is how many layers of meaning and association can cohere around a single work. Yet his proto-forms are allusive rather than representational. His work is not figurative, but often intimately recalls the body. The work isn't architecture, but its forms are elemental. There's no overt symbolism, but an implicit suggestion that related bodies of knowledge exist outside of the work itself. In our secular world, Kapoor generates resonances that are visceral, sensual, and poetic, bringing to his art an expansive, mythic dimension.

8— Ananda K. Coomaraswamy, "The Hindu Tradition: The Myth," in *The Essential Ananda K. Coomaraswamy,* ed. Rama P. Coomaraswamy (Bloomington: World Wisdom, 2004), p. 270.
9— Pamuk, *My Name Is Red,* p. 186.

THE CULTURAL HYBRID
The world as a work of art that gives birth to itself—
—Friedrich Nietzsche, "The Will to Power as Art"[10]

Having described four fundamental, and interrelated, aspects of Kapoor's art, it might appear that his task to date has been a thoroughgoing rejection by example of the late modernist project, including truth to materials, anti-illusionism, and the autonomy of art. The reality, however, is more complex. Kapoor's work has developed, in part, through a deep and ongoing dialogue

Dragon, 1992

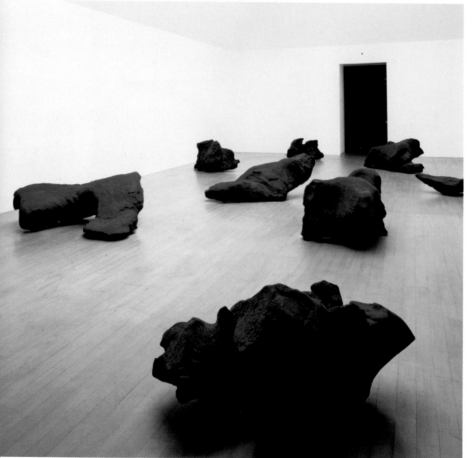

with minimalism and conceptual art. His work shares these movements' profound aversion to the notion of art as a process of self-expression, compelled instead by an impulse toward *noncomposition*: methodological

10—Friedrich Nietzsche, "The Will to Power as Art," #796, in *The Will to Power*, ed. W. Kauffman (New York: Vintage, 1968), p. 419.

approaches that distance the subjectivity of the artist from the work of art. This tendency underpins all of the most influential developments in American art of the 1960s.[11]

Like minimal art, Kapoor's work eschews all evidence of the artist's hand. Indeed many of his works could not attain their high level of finish without the use of industrial materials and processes. Similarly, there is a frequent preference for geometric and symmetrical forms, limiting the compositional decisions involved in their making. Other bodies of work deploy forms that are given, like the naturally formed rocks of

Past, Present, Future, 2006

Dragon, 1992, or captured by chance, like the trapped air bubbles of *Untitled*, 2007. Yet others make a mechanical process itself the subject: *Past, Present, Future,* 2006, is a hemispherical form described by the mechanical rotation of an arc through 180 degrees. In the manner of conceptual art, Kapoor

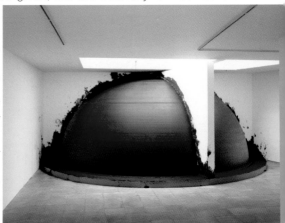

Untitled, 2007

describes making art as a process of research, lead by the work rather than by the artist's imagination. The implications of one piece lead to the next. He is also inclined to work serially, developing variations on one idea, form, or material, bringing it to new levels of complexity and elaboration. Thus we might compare the mechanism of *Past, Present, Future* to that of Jasper Johns's *Device Circle*, 1959; or the capture

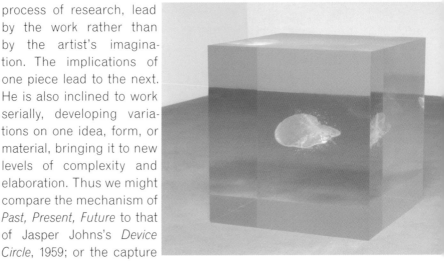

of a natural element in *Untitled*, 2007, to Hans Haacke's *Condensation Cube*, 1963–65; or the theme and variations of an installation of colored concave mirrors with a series of Donald Judd's boxes. In each example,

11— The conventional notion of artistic composition involves the unfolding over time of aesthetic judgments whereby line, form, and color are brought together to create a satisfying result. This process, entirely dependent on the subjective decision making of the artist, was radically challenged in the 1960s by artists' adoption of a range of noncompositional strategies in making their work. In movements often considered divergent, from pop to minimalism to conceptualism, noncompositional approaches identified a shared imperative to negate subjectivity. The work of noncomposition can be recognized when, for example, the appropriated image renders pictorial invention obsolete, when research replaces inspiration, when chance rules over choice, when repetition erases spontaneity, when the machine is preferred to the hand,

Kapoor has absorbed the strategies of noncomposition and embraced its ethos of self-erasure.

More remarkable still is that in Kapoor's art the noncompositional critique of the romantic model of artistic creation merges with an Indian concept of self-manifestation. *Svayambhu* is a Sanskrit term referring to that which is created of its own accord rather than by the hand of man. Thus stones from the Narmada, a holy Indian river, which have been polished into elliptical shapes by its fast-moving currents are revered as lingams, sacred objects that represent the god Shiva. Kapoor's

fascination with "the mythology of the self-made object" leaves no doubt that he regards it as a fiction—albeit an essential one—in the creation of his own work.[12] For example, in the major installation titled *Svayambh*, 2007, a giant block of red waxy material is moved mechanically through a series of doorways which appear to carve it to their shape.[13] The wax is not literally carved by the doorways although it appears to be; hence the characterization as fiction. It is also true that noncompositional strategies never truly erase the artist, but rather elaborate the creative process as a complex interaction between subjective and nonsubjective elements. For American artists in the 1960s noncomposition represented a demystification of creativity, which in the 1950s had been predominantly identified with inspiration, personality, and uniquely individual gesture. In contrast, Kapoor's work poses the question: if creativity does not belong exclusively to the artist, where else might it reside? In the concept of *Svayambhu*, Kapoor identifies the mythic potential of noncomposition. Rather than remythologize the artist as romantic genius, Kapoor invokes cultural myths of origin. In doing so, he implies that sources of significance reside beyond both the object's form and the artist's personality, and that the making of meaning is a fundamentally social act.

Jasper Johns
Device Circle, 1959
Encaustic and collage on canvas with wood
40 x 40 in.
(101.6 x 101.6 cm)
Art © Jasper Johns.
Licensed by VAGA, New York, NY

Hans Haacke
Condensation Cube, 1963–65
Water in plexiglass box
10 x 10 x 10 in.
(25.4 x 25.4 x 25.4 cm)
Museu d'Art Contemporaini, Barcelona, Spain
Gift of the National Committee and Board of Trustees
Whitney Museum of American Art
© 2008 Artists Rights Society (ARS), New York / VG Bild-Kunst, Bonn

when system abolishes gesture, or when seriality generates form.
12—Anish Kapoor in "Mythologies in the Making: Anish Kapoor in Conversation with Nicholas Baume," in this publication, p.36.
13— *Svayambh* was made for the Musée des Beaux-Arts de Nantes in collaboration with the Haus der Kunst, Munich.

TO MANIFEST THE MANIFOLD

To abstract is to express the virtuality of nature, to
make known some instance of its possibilities, to actualize a relation out of infinite
relationality, to manifest the manifold.

—McKenzie Wark, *A Hacker Manifesto* [14]

And it seemed it was not a mirrored object but an object full of mirroredness—

—Anish Kapoor [15]

As Anish Kapoor's art casts an eye toward history and culture with its proto-forms and myths of origin, it also looks forward to new materials, new spaces, and new forms of visuality. Although his ideas are generally manually sketched and modeled rather than drawn on a computer, Kapoor's art has captured aspects of the new visual language of our digital era with remarkable prescience. The uncertainty of objects that morph from one state into another, the warping and abstraction of contingent spaces, the seamless dynamism of structural skin—each of these core elements in his art is deeply resonant with the new physics of digital representation.

Contemporary visuality proposes a new spatial model based on neither the deep pictorial space of Renaissance perspective nor the empirical flatness of modernist abstraction. David Joselit has described it as "the epistemology of the hyperlink: a displaced or virtual depth that is composed of multiplied surfaces." The experience of *Cloud Gate* is just such a multiplication of surfaces, as is the encounter with *S-Curve*, 2006, which translates the former work's transition from convex to concave space into a single ribbon of undulating polished steel. Its shallow depth verifies the impossibility of its form concealing deep space; instead its skin becomes a hyperactive screen on which the viewer appears live, in multiple, simultaneous, abstracted iterations. Neither deep nor flat, the activated space of *S-Curve* hovers in front of the object. This is not a metaphysical space, one where artist and viewer have consented to a collaboration of imagination. In *S-Curve* we experience the virtuality of nature. The effect of Anish Kapoor's work is not so much to conjure illusion, but rather to manifest the abstract, fugitive possibilities of the real. It takes us to the very threshold of the visible world where, as Major Tom so memorably observed, the stars look very different today.

14—McKenzie Wark, *A Hacker Manifesto* (Cambridge: Harvard University Press, 2004), #008.
15—Kapoor in "Mythologies in the Making," in this publication, p. 54.

S-Curve, 2006

MYTH
IN THE
ANISH
IN CONV
WI
NICHOL

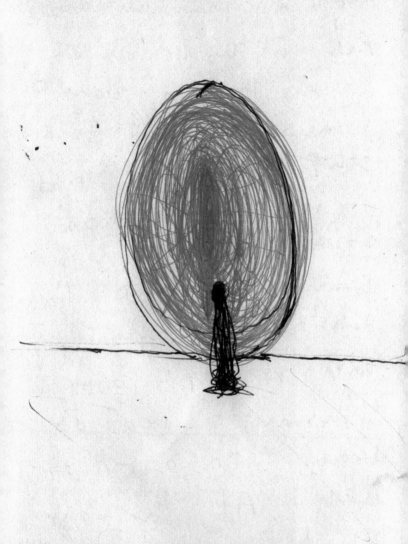

Red at the Centre?

Red is the colour of
body. to say colour is
in-accurate as it is the
stuff of body. Since
it is the principal
object of Art to trans
form, trans mute, trans
substantiate, it is
my principle aim to
trans mute red of
body into a red of
sky. At the 'edge
of the world' does this

(1999)

Red is at the center
as blood it is the
pulse of life. As
blood it is the ritual
liquid which gives life
Through red. I partake
of Body and pass through
to spirit.

Red is at the centre
it is eyes turned inwards
a vission of the interior

~~the interior~~ I know.
that dark black Red
the terror of a place I
know. A return

Red at the Centre
is whole. Wholeness is
formed by a full
horizon

wholeness connects inner
and outer. The red of
inside and the red of outside
I make Art from this.

OLOGIES
MAKING:
KAPOOR
VERSATION
TH
AS BAUME

Untitled, 2007

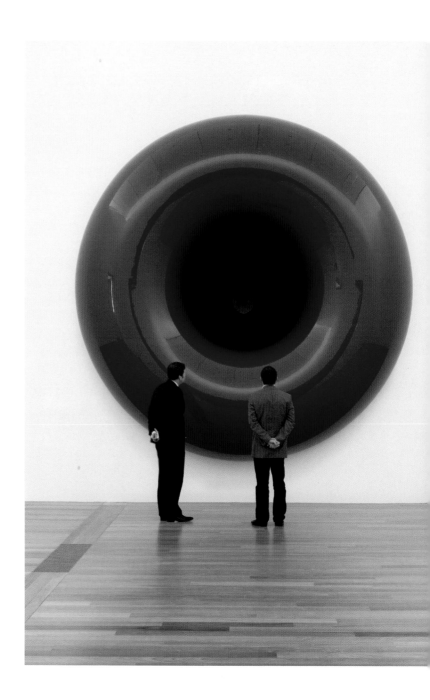

You were born and raised in India before going to art school in London, where you have lived ever since. How can we understand the intersection of different cultures in your work?

I use red a lot. I've gone so far as to title a work *My Red Homeland*. It's true that in Indian culture red is a powerful thing; it is the color a bride wears; it is associated with the matriarchal, which is central to Indian psychology. So I can see what leads me there culturally, but there's more to it. One of the ways color has been used in art since the eighteenth century is to move, as in Turner, from color to light. My tendency is to go from color to darkness. Red has a very powerful blackness. This overt color, this open and visually beckoning color, also associates itself with a dark interior world. And that's the real reason I'm interested in it. Is that Indian? I don't know that it matters.

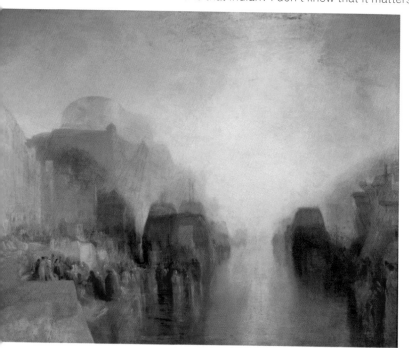

Joseph Mallord
William Turner
***The Harbour of
Brest: The Quayside
and Château,***
c. 1826-28
Oil on canvas
68 x 88 in.
(172.7 x 223.5 cm)
Tate Gallery, London,
Great Britain

PAGE 31

When I was a student in the U.K. in the mid '70s, there was Anthony Caro and the Greenbergian formalist approach to sculpture, which I found completely without any relevance. There were artists, like Joseph Beuys and Paul Thek, who worked in other ways. It's as if there is a different poetic mood that you need to bring to the object, otherwise you can't see it. In other words, artists don't make objects, artists make mythologies, and it's through the mythologies that we read the object. That idea

seemed to question the status of the object; it seemed to say the object is an uncertain thing. And that's what I've been exploring ever since!

To what extent do you see an Indian influence on your work?

Could one do an analysis of my form in terms of Indian aesthetics? I expect one could. I'm drawn to form that seems to have multilayered interpretive possibility. Yet I'm not interested in overtly readable symbols. As much as I love Brancusi, a bird in space is too obvious for me—I think we've moved somewhere else. Negative, interior form interests me. I'm also drawn to form that has a kind of iconic readability, what I call "proto-form."

Paul Thek
Ark, Pyramid, 1972
Installation:
Documenta 5, Kassel,
Germany, 1972

Joseph Beuys
**Stripes from
the House of
the Shaman,
1962-72**, 1980
Felt, wood, coats,
animal skin, rubber
tube, pamphlets,
copper, quartz and
ground minerals,
pigments.
Overall (approx.)
590 ½ x 236 ¼ in.
(1500 x 600 cm)
Purchased 1981
National Gallery of
Australia, Canberra

Are you referring to particular architectures?

For example, Jantar Mantar, the observatories made by Maharajah Jai Singh, a Rajasthani king, around 1730. They are absolutely amazing, and also mysterious in their architectonic form. For example, there are staircases that just go up to the sky. They are for observing the stars, but they don't lead to anything. The sundials are also incredible.

The idea of an observatory seems appropriate in relation to your work, which is so much about the acts of viewing and perceiving, of charting inner and outer space.

Absolutely, and I respond very strongly to the instruments' physical relationship with the ground; some of them are even submerged in the earth. And there is also a very interesting relationship to the idea of the cosmos. One could look at all the great symbolic monuments, but I'm just as interested in the little huts on the roadside. There's huge variety and invention. Take the open-air mosque; it's a wall without a building. That's so powerful. It seems to magically enclose an area without there being any buildings, just a wall. It says something about the way an object comes to life, comes to infiltrate physical space, but it also says something about the way space itself is a philosophical entity and not simply where things happen.

Jantar Mantar,
Jaipur, India

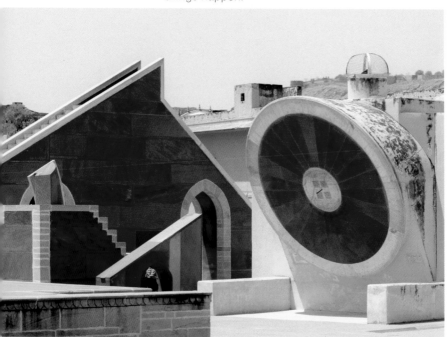

It seems that in the early period of your career being labeled an Indian artist risked a kind of marginalization. Do you think that still holds true today?

It really has changed a lot over the past twenty-five years. The whole attitude to travel has changed, the idea of foreignness. When I first came to the U.K. in '73, at art school I was asked over and over again, "Do they have cars in India or do people go around on elephants?" I'm serious! There has been a huge cultural shift, and now India is one of the great emerging economies. These changes in context and perception can be a real force.

As the cultural context has changed, so too has your position as an artist, as an established figure in the international art world.

Yes, but I've always taken the position that my psychobiography is incidental—it's a tangential starting point for the work. You know, I'm not Tracey Emin! This is where two traditions—the modernist and the Asian—coincide very well. The modernist art that I admire views the self as a springboard from which the work takes on a life of its own. You find a very similar attitude in Asian art, where the self isn't the entity out of which all expression is determined. The self is only a means. That's why I keep saying, "I have nothing to say."

Is that where the idea of the work that makes itself comes in?

I have always been interested in the mythology of the self-made object. As if without an author, as if there by its own volition. In Indian thought that's a pretty strong idea.

What is it that attracts you to the idea of a work that is the product of something other than the artist's subjectivity or imagination?

It is complicated. Fundamentally, I feel that we are religious beings and not simply biological ones. When one sets out to look for a language that gives meaning at some level to the abstract, one of the meanings that occurs is, in very broad terms, religious. Now I don't mean doctrinal religion, but a sense that there are some fundametal moments, and one of them is origination. Life in a process of willing itself into being. Of course the notion of objects that make themselves, that are without authorship, is a kind of fiction. It is a useful fiction about the making of the object and its content, and it has very straightforward practical applications.

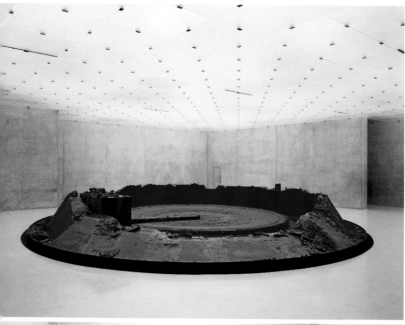

My Red Homeland,
2003

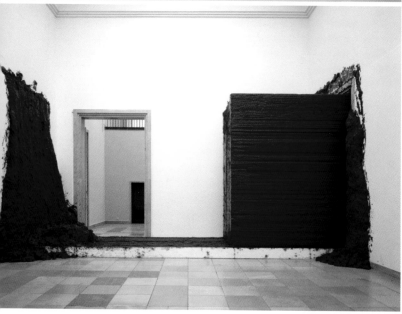

Svayambh, 2007

What, then, are the ways in which one might consider your objects as self-made? One is appropriation—say, the appropriation of a form from architecture, or from nature; a given form that is somehow adapted. A more "pure" appropriation might be bubbles of air encased in resin, with its literal capture of a natural phenomenon. You did not make the form but you created the conditions under which it could be generated. Or there is the idea of the mechanically "produced" form of *Past, Present, Future*, a gesture that makes literal the idea of the self-made object. Here are at least three different examples of how nonsubjective creativity is manifested in your work.

Yes, the "unauthored" work is a fiction, but still a very important way of thinking about a problem.

And for you that relates in a broad sense to cultural myths of origin, from the Aboriginal dream time to the Biblical story of Adam.

Exactly. The idea of self-manifesting seems to do away with God and all the authorial problems of the making of objects. In the case of *Past, Present, Future* the fiction seems to say, take a wall, cut a disk out of it, rotate it in space, and it results in an object. It is a very old way of making sculpture. There is something about the symmetry it proposes which I think is very interesting and relates to basic forms and all sorts of different architecture. Of course I've always made a lot of symmetrical forms, forms that seem to propose that they were made by moving something in 360 degrees or 180 degrees or some variation.

So, rather than "express" the self, there must be a kind of resistance to the self, or a collaboration between the self and the external?

The piece I made at the Haus der Kunst is a big block of red waxy material which passes through the doors of the building. It is bigger than the doors, so it is "carved" by them. The result of having set up this process is a form that is orthogonal—a big block. Again, it uses the fiction of autogeneration.

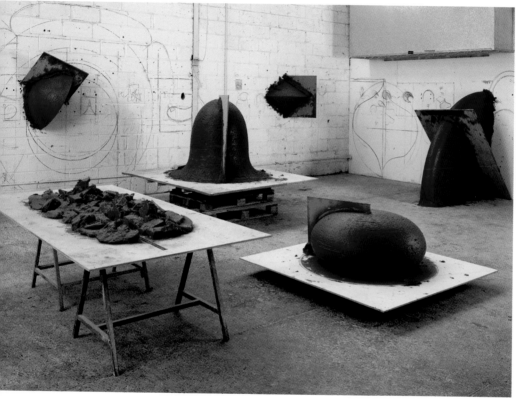

Studio, 2005–06

In the resin pieces there is a dialogue between the static, frozen moment of the bubble and the mobility it implies.

The first one I made was called *Space as an Object*, 2001. When a bubble is encapsulated in a transparent block it is as if, in some "proto" sense, space becomes an object. Air it may be, but space it is too. It is also very much in a state of becoming; there's an implied motion in these bubbles. They are random. The material is cured under both heat and pressure. When you pour the material, there is always air in it somewhere. The trick has been to learn how to get the air into the center—but the forms that emerge are completely random. I am putting a whole series of these objects together—it's like a collection of butterflies.

Given that your work always has a very strong aesthetic signature, it seems counterintuitive to hear you talk about the self-generating object. Yet it is a familiar paradox that for so many artists since the 1960s the imperative to get outside of the self actually leads to a very strong artistic signature. A LeWitt is clearly a LeWitt; a Judd is clearly a Judd. Still, some kind of resistance to or negation of the self is essential to the strength of this work. In my view, that is because the fiction of an all-controlling subjectivity is unsustainable in our period. The work of art that engages with processes beyond the self seems more truthful about what it is to experience life today.

Abstract art either works very hard to keep reference at bay or it does the opposite, which is to accumulate reference unto itself. I am interested in layers of meaning. The red block at the Haus der Kunst takes on all kinds of references. There is a sense of geology, of body and blood, of some deeply visceral realities. The building is shitting this thing. In this work architecture comes to be not just a mirror of the self, but it partakes of the self in some much more profoundly psychological way. A straightforward gesture can generate a whole host of metaphoric parallels. One has to pose a fiction very carefully hoping that some of these layers can accumulate on top of the basic proposition.

And that process, with its useful fictions, has been a very fruitful one for you.

When you interrogate the idea of the autogenerated in relation to my work, I can't help talking about the religious dimension, the myths of origin. As Gauguin put it, *Where Do We Come From? What Are We? Where Are We Going?*

Your sculptures are often characterized by formally refined, perfectly articulated and executed forms. They work by being very distinct from anything around them. *Cloud Gate* is surrounded by both built and natural forms, yet it is extraordinary because it is so completely different from everything around it, which it also reflects and transforms. It almost seems magical.

I've always been interested in the magical. When I'm working on something in the studio I often find myself wondering how good it is, if it's doing enough. What I mean is not whether it's working formally—that's relatively straightforward—but whether it generates enough of that nonphysical, non-object-related character. The other side of that coin is when whatever it's doing becomes too active. It's a short trip from Disneyland to something truly mysterious. Truly mysterious implies that there is something else going on—it's a matter of meaning.

There are striking antitheses within your work. You've developed the mirrored objects to a state of

It must be that I'm perennially uncomfortable! Somewhere in the work there is a real search for love and death, blood and guts. There's also a lot of work that seems to be very cool and distant. For

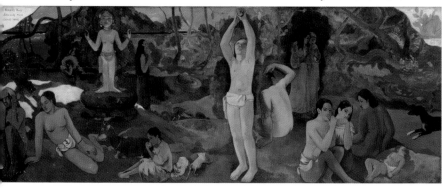

Paul Gauguin
Where Do We Come From? What Are We? Where Are We Going?, 1897–98
Oil on canvas
54 ¾ x 147 ½ in.
(139.1 x 374.6 cm)
Museum of Fine Arts, Boston
Tompkins Collection-Arthur Gordon Tompkins Fund, 36.270

PAGE 39

extraordinary refinement and surface perfection. Their solid structures notwithstanding, they seem to liquefy before our eyes. You then produced a body of wax pieces which are visceral, bodily, and process-based. They carry a strong sense of touch, while the mirrored works eschew the hand in every way.

me the two things are completely near each other: it's not that the one is cool and the other hot, it's that they both partake of the same inner world. One of the things I've learned is that it's not necessary to say everything all the time. It's okay to make work that alludes to bodies of knowledge which previous work has dealt with—without having to encapsulate.

It seems to me that there are two basic ways of working: one is that the artist leads the work and the other is that the work leads the artist. The work ought to lead the artist, not the artist the work. For the artist to lead the work one must assume that the artist knows what he or she is doing and has

something to say. When the work leads the artist the process is one of discovery. I don't have anything I'm dying to say, but I do know that if I allow myself to excavate, to research, the process leads to meanings that could never have been logically imagined.

That reminds me of one of my favorite of LeWitt's "Sentences on Conceptual Art": "The artist cannot imagine his art, and cannot perceive it until it is complete."

What I've done over the years is to have evolved certain languages. To paraphrase, there's the pigment language, the void language, the mirror language, the wax language—as well as a few others. What I want to do is innovate in all of them. Of course they all relate to each other, but in many ways each is quite different as well. I feel that gives me great freedom. I see similar ways of thinking in the work of other artists, Sol LeWitt being a prime example.

Let's look at these "languages" in more detail, starting with the pigment pieces.

What is important about these works is not that they are made out of pigment. The curious thing is that they appear to be made out of pigment. "Truth to materials," which was a big thing when I first started making sculpture, seemed to hold the whole thinking about sculpture down to the nuts and bolts of its factual realities. It said that what you see is what you get, and I think that art is exactly the opposite. What you see is not what you get! For me the illusory is more poetically truthful than the "real." People would often wonder about the pigment pieces—are they really made of pigment? Well, some of them are and some of them aren't, and that has never been a problem for me since I believe an object is read through its skin. I wanted to put truth to materials to one side and say that art is about lots of things that are not present.

Yes, although your works never feel like the relics or by-products of a performance. They are fully realized, intentional objects.

I suppose I have a foot in both camps! I like the idea that the object has its own Gestalt, its own resolvedness, even as it accumulates other layers of meaning. I'm not talking about narrative. They may have references, but they are not narrative objects: they don't delineate the process of their own making. At the same time, there is a suggestion of ritual in the layout, the sprinkling of pigment, the delicacy of the surface.

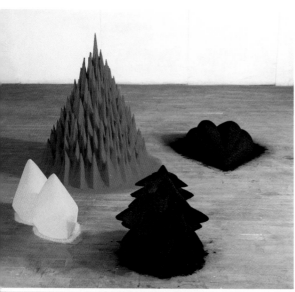

White Sand, Red Millet, Many Flowers, 1982

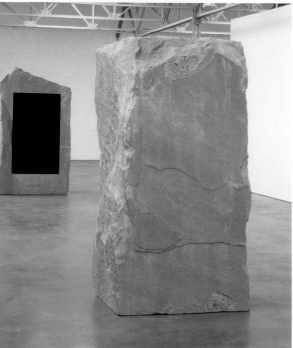

Untitled, 1992

1000 Names, 1982

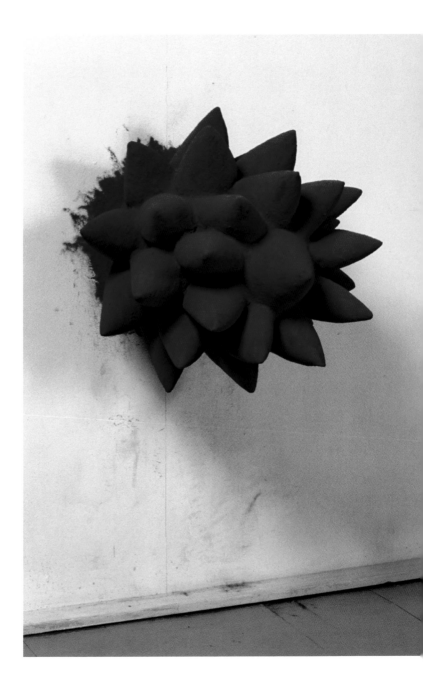

While I have called them "fully realized" objects, they also challenge the status of the object. They seem to be about borders and limits, about the surface and skin of the object and where it begins and ends. This is, of course, a consistent theme in your work.

Yes, I continually come back to questions about the status of the object: How fully is it in the world? How much is it what it says it is and how much is it something else? Where is the real space of the object? Is it what you are looking at, or is it the space beyond what you are looking at? In a way this is why I chose the title *1000 Names*. It is as if these objects are the one-tenth of the iceberg that is visible. They define the plane on which they are shown, whether it is the floor or the wall, and they protrude into the space. So many of the works that I've made subsequently come back to this idea: that the space itself is only notionally defined, that there is something beyond it. It is a proposition about space treated as a poetic idea.

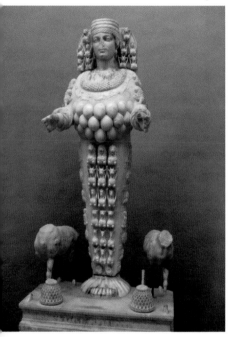

Artemis
Archaeological
Museum,
Selcuk, Turkey

The pigment pieces are largely geometric and refer to archaic or originary forms; forms that like the flower or the spiral come from nature, but that also inform architecture in a very basic way. You end up with a formal language that is organic but also culturally rooted.

Absolutely. I suppose there are two things: one is what I'd call proto-architecture, and the other is biological. In a way it is both the flower and the breast.

The figure of Artemis immediately comes to mind.

Exactly.

Of course these forms are very stylized, and are also unified by the mono-chrome pigment. How did you develop the forms; did you model them in clay or make drawings?

I drew them; I've always drawn things on the walls in the studio.

Why drawing on the wall rather than in a sketchbook?

I do both, but a sketchbook is normally closed. You have to open it and then the pages are sequential. The great thing about drawing on the studio walls is

Mother as Mountain, 1985

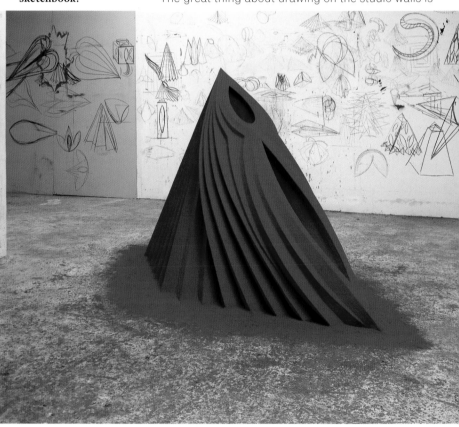

that it is a constant if only tangentially observed presence. One drawing will lead to another or might lead to an object. So they infiltrate my consciousness in a way that is fruitful.

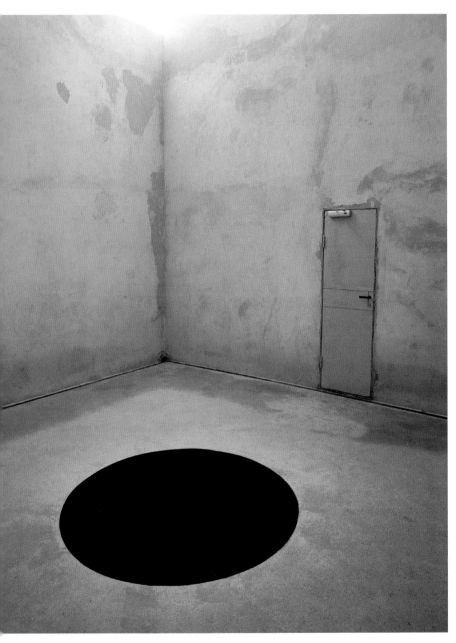

Descent intoLimbo,
1992

Let's turn to *My Body Your Body*, which is among your works that relate to the void.

My Body Your Body is set into the wall, so it is a space beyond the gallery space. Like the pigment pieces, it extends the idea of manifestation, by which I mean it implies a sense of the present and of place. The pigment pieces worked with ideas around architecture and the body. The void pieces take those ideas one step further as they go beyond architecture; they live as holes in the architecture rather than as objects in the space. They bring a new complexity to the problem of space from the point of view of the body. They are about darkness and the uncanny, something half-known or half-remembered. Darkness is something we all know; it is the condition of things when the lights are switched off, but in a way it is also an internal view of ourselves. The work makes a material move towards the non-object, which is certainly perceptual but it is also psycho-physical.

How does the notion of "the infinite" play out here?

These works always propose a picture plane that directs the viewer towards a deeper interior. Maybe the quintessential work in this series is *Descent into Limbo*, which is a hole in the ground. It reads not like a hole in the ground, but like a black carpet sitting on the floor. It is not an empty dark space, but a space full of darkness.

What are the two bodies suggested in the title *My Body Your Body*?

One, if you like, is darkness. The other is bodily space. At first it looks like a flat picture on the wall, and then there is the dawning perception that it is actually a volume, and that the volume is curved, long and narrow, and reminiscent of various holes in our own bodies. I like the fact that the viewer is implicated in the act of looking. I am interested in the idea that a work of art can say, "Come on, come over here. I can engage you deeply and my space infiltrates yours." That may be why over the years I have been very drawn to exotic materials that seem able to pull you in. Scale is another thing that can entice the viewer into the object.

Which leads naturally to your interest in highly polished surfaces.

Yes, that's another stage in this adventure of mine. All of the works we have discussed, from the pigment pieces through the void pieces and some white ones on the way, have dealt with the idea that deep space is one of the things that seem to confuse the

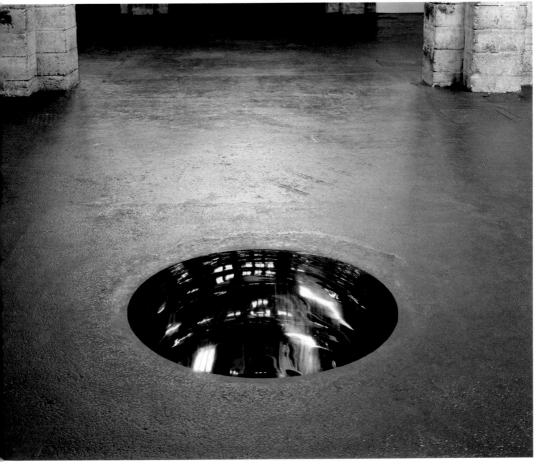

Iris, 1998

status of the object. At some point in the mid '90s I began to wonder if mirror-polished objects had the same spatial qualities. The first mirror-polished object I made was rather akin to *Iris*. It was a three-quarter sphere, polished on the inside, set behind a wall. To my astonishment it had the same kind of perceptual skin across it as *Descent into Limbo*.

And it seemed it was not a mirrored object but an object full of mirroredness. The spatial questions it seemed to ask were not about deep space but about present space, which I began to think about as a new sublime. If the traditional sublime is in deep space, then this is proposing that the contemporary sublime is in front of the picture plane, not beyond it. I continue to make these works because I feel this is a whole new spatial adventure. To make new art you have to make a new space.

That interests me because it goes to the heart of what is contemporary about your work. In its formal qualities, particularly the mirror-polished pieces, is a sense of both limitlessness and morphological dynamism. The sense of an object that morphs from one thing into another as you experience it. That when you interact with it you enter a space which seems neither on the surface nor inside. The work posits a kind of compressed energy, and that resonates very much with changes in our perception of the world. Our understanding and experience has been exploded onto both a micro and macro scale. The visual language that describes the world is changing; these works capture that transformation in a quite extraordinary way.

Space is perhaps one of the only truly abstract entities. One of the things about mirrored objects, and especially the forms that are inside-out, is that they seem to be very active, to be in various states of becoming. I made an earlier piece in concrete where the floor in the room turns into a funnel; the whole space is in a process of involution. The mirrored objects seem to take that process one step further. I am intrigued by the analogy with digital space, the Internet, and by the development of ideas in physics.

To what extent is the computer a useful tool for you?

The making of *Cloud Gate*, for example, involved a great deal of computer modeling to analyze the form in order to make it well enough. But I don't use it to draw anything. When I make a model it is a much more manual process; for *Marsyas* I made a stocking model. The computer may be a great way to discover something, but I've yet to use it that way.

Casting steel at the scale in which you work and with the accuracy that your mirrored pieces demand must be a formidable challenge.

It can become a quite impossible pursuit of perfection. The interesting thing about a polished surface to me is that when it is really perfect enough something happens—it literally ceases to be physical; it levitates; it does something else, especially on concave surfaces. Brancusi made a number of polished objects, such as the heads, that have convex surfaces. Jeff Koons has also used polished convex surfaces. But what happens with concave surfaces is, in my view, completely beguiling. They cease to be physical and it is that ceasing to be physical that I'm after.

Constantin Brancusi
Prometheus, 1911
Polished bronze
6 ¾ x 9 in. (17 x 23 cm)
Musée National d'Art
Moderne, Centre
Georges Pompidou,
Paris, France

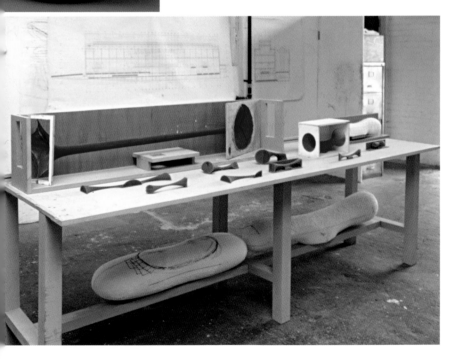

Models for **Marsyas**

In different ways, each body Exactly.
of your work makes the
status of the object uncer-
tain, but at the same time
also makes the subjective
experience of the viewer
uncertain. In this way they
reflect on our uncertain
state as subjects in an ever
more spectacular world, a
world of dazzling beauty,
power, and threat. These
objects capture an experi-
ence of the liquefying and
dissolving of solid form—
which is a thrilling, seduc-
tive, and dangerous thing.
It literally throws us off bal-
ance as it suggests a world
beyond our grasp.

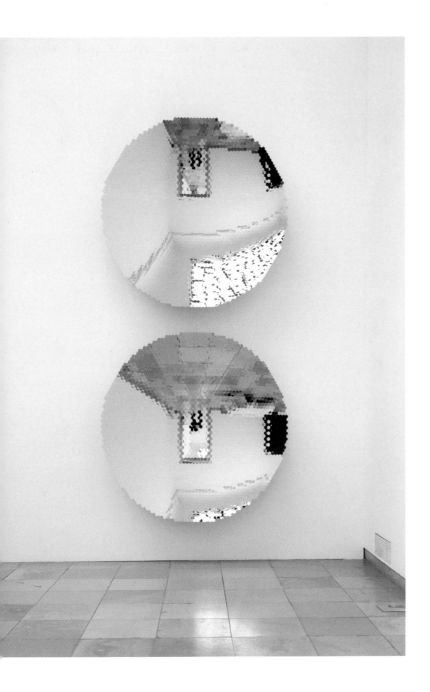

Hexagon Mirror,
2007

SELE WC

ECTED

ORKS

*1000 **Names***, 1979–80

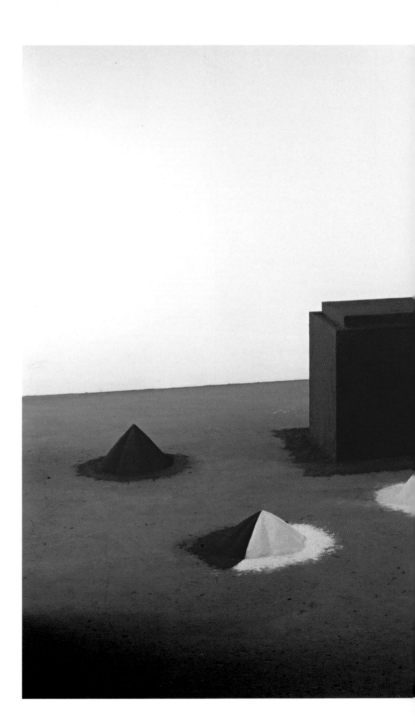

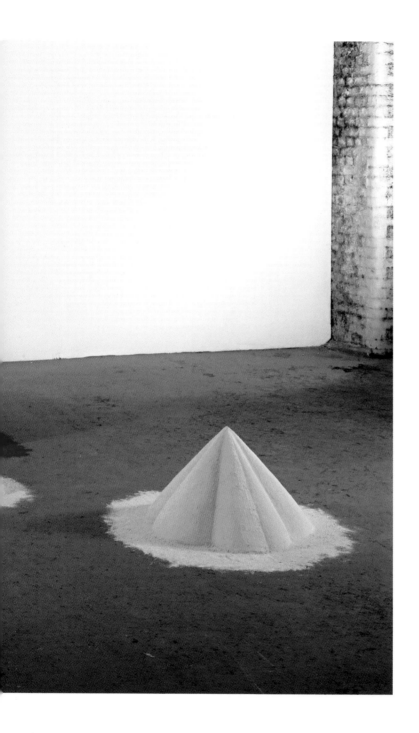

ANISH KAPOOR

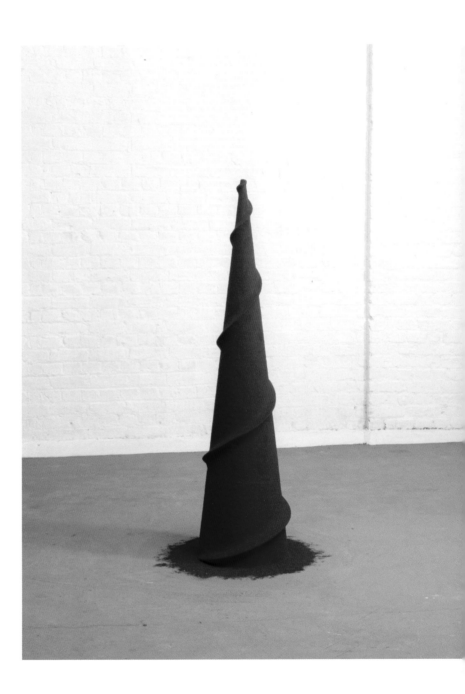

ANISH KAPOOR

*1000 **Names**,* 1979–80

Untitled, 1983

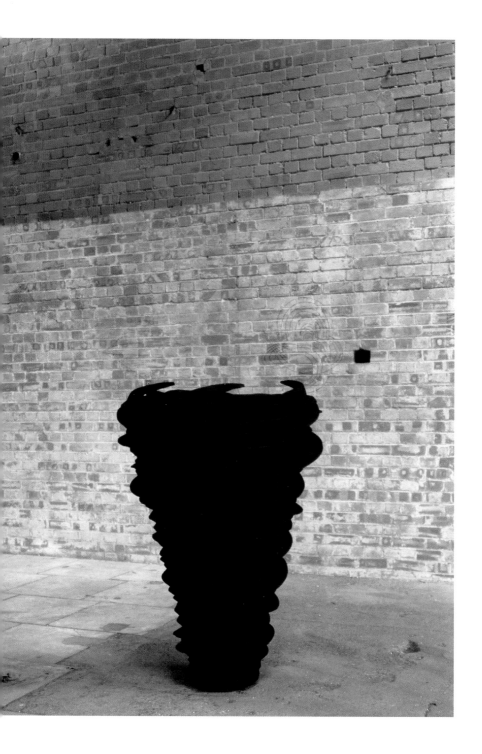

ANISH KAPOOR

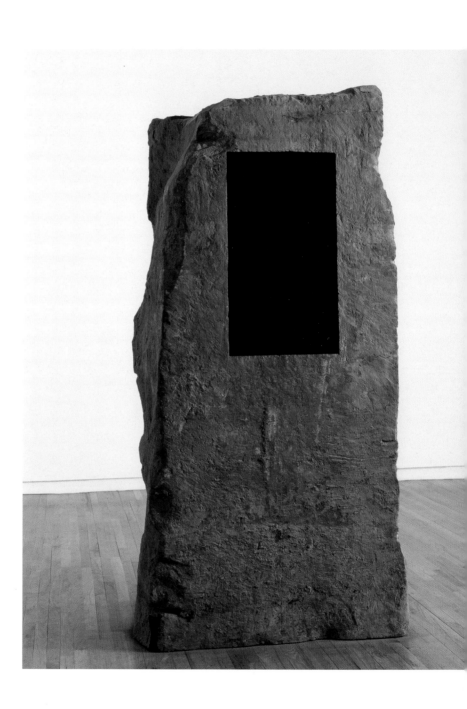

ANISH KAPOOR

Adam, 1989

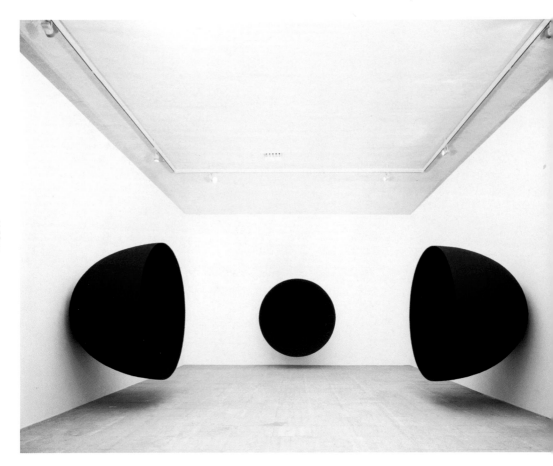

Untitled, 1990

When I am Pregnant,
1992

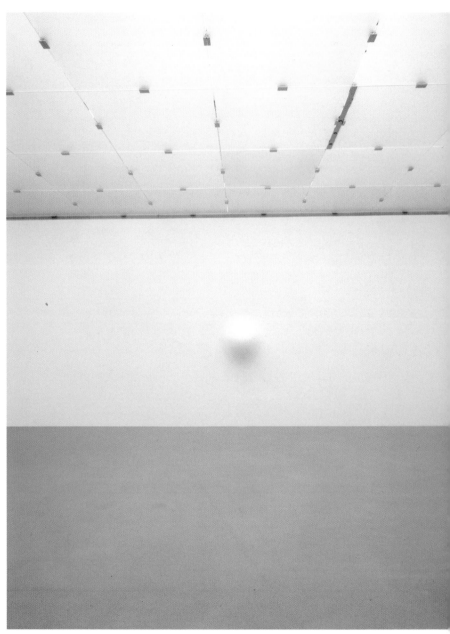

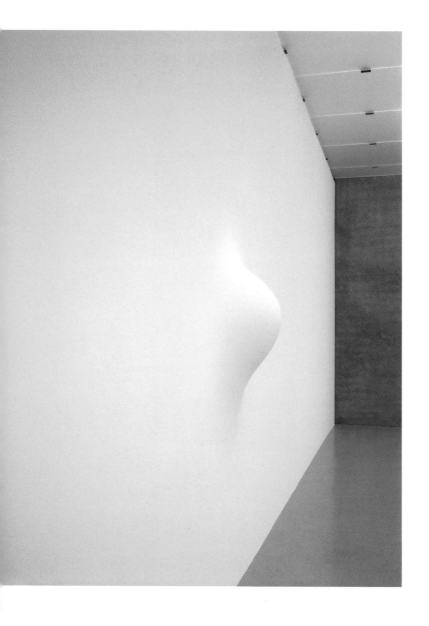

ANISH KAPOOR

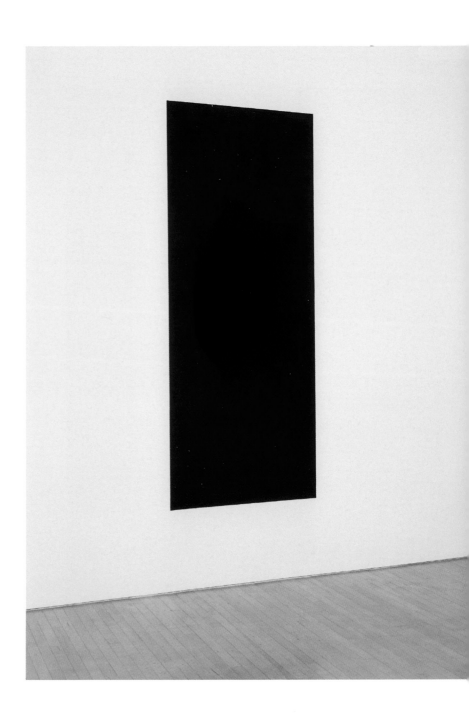

ANISH KAPOOR

My Body Your Body,
1993

*Turning the World
Inside Out II*, 1995

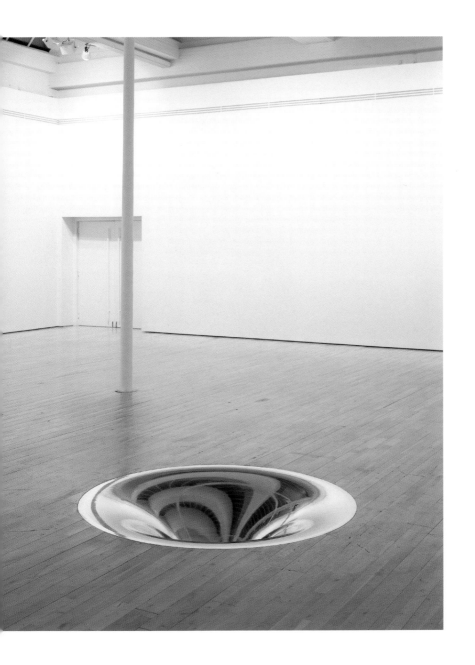

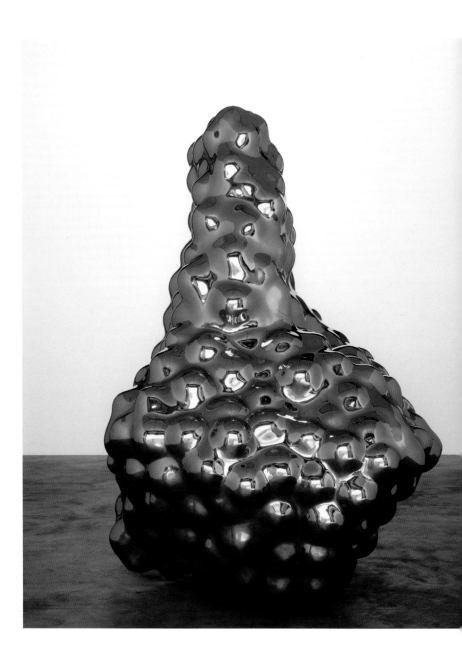

ANISH KAPOOR

*Making the World
Many*, 1997

Ghost, 1997

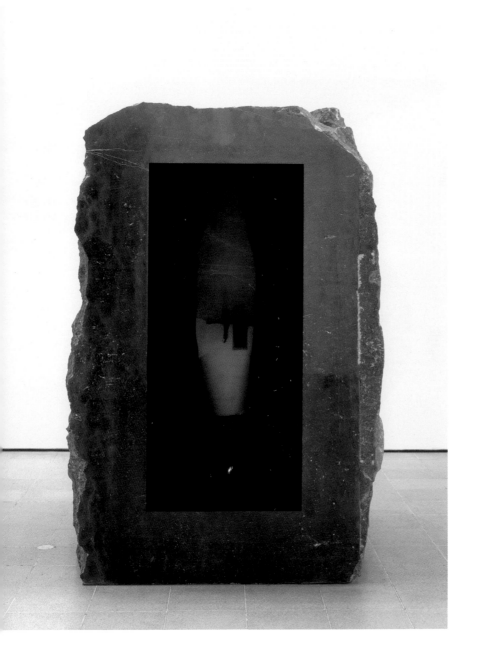

ANISH KAPOOR

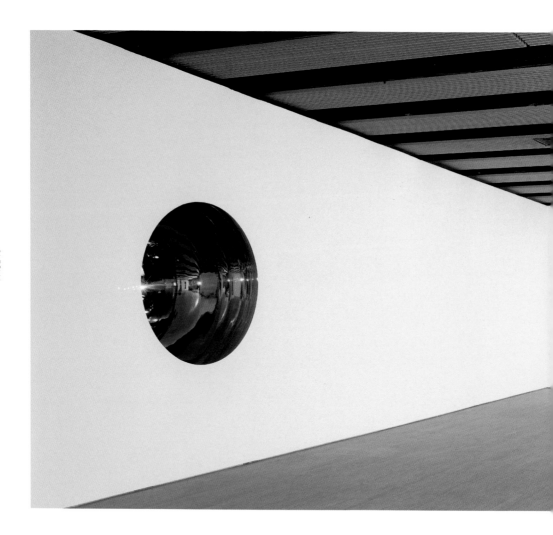

Iris, 1998

Resin, Air, Space II,
1998

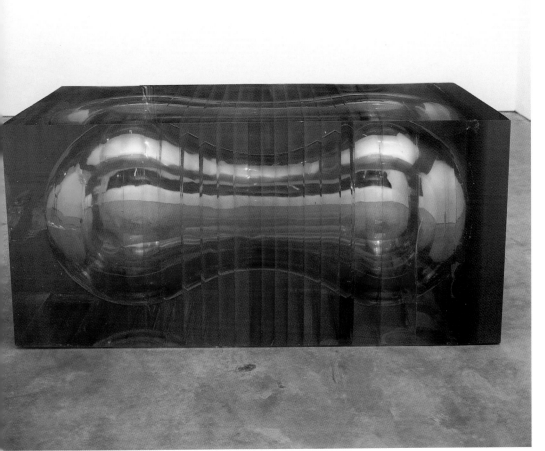

Her Blood, 1998

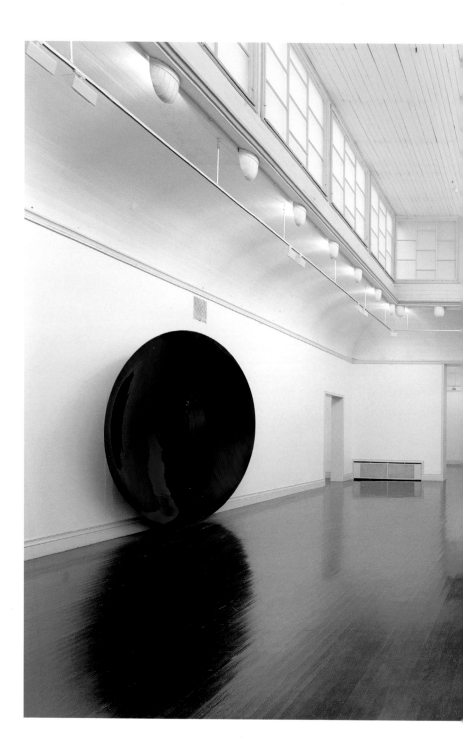

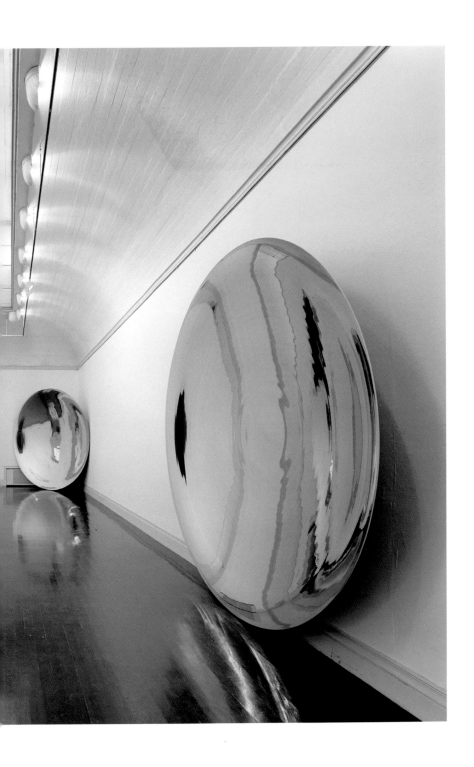

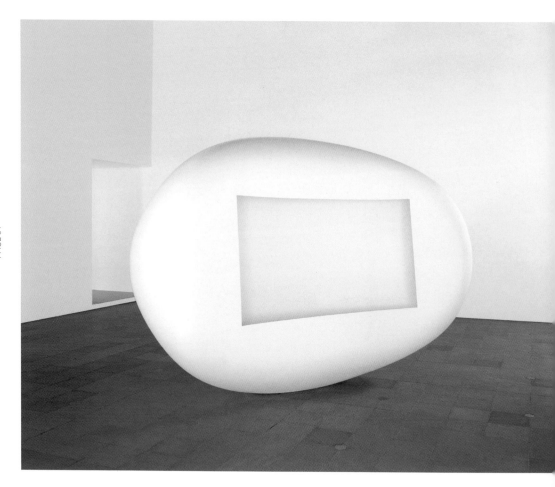

ANISH KAPOOR

Untitled, 1998

White Dark VI, 1998

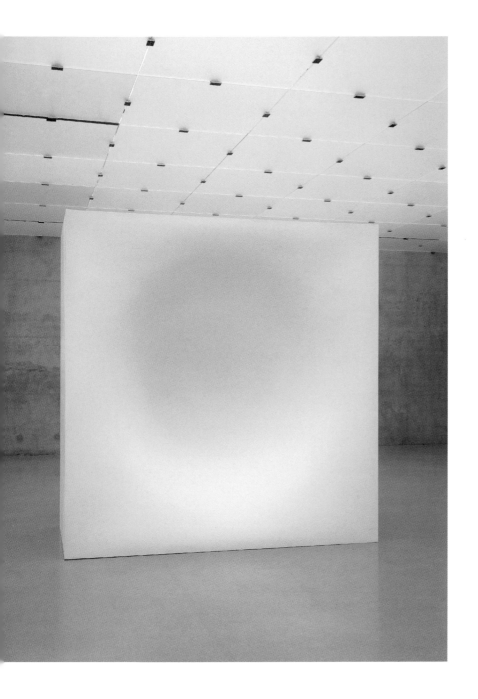

ANISH KAPOOR

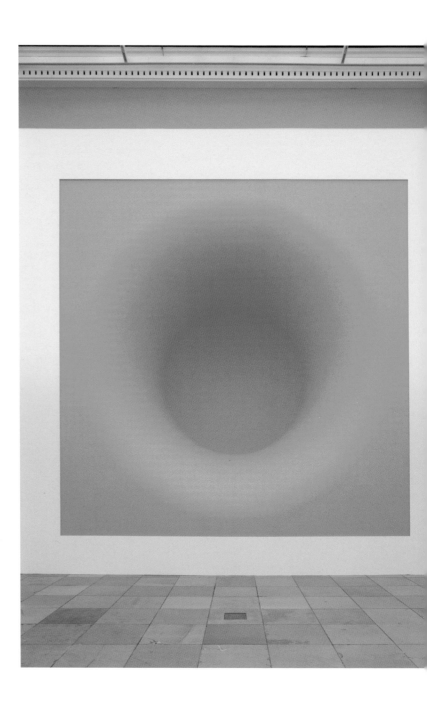

ANISH KAPOOR

Yellow, 1999

Past, Present, Future,
2006

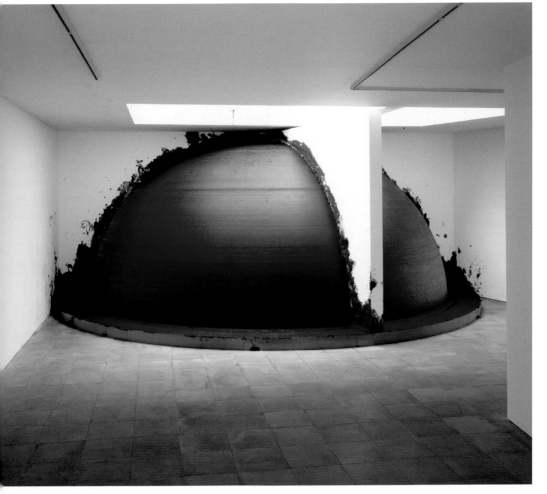

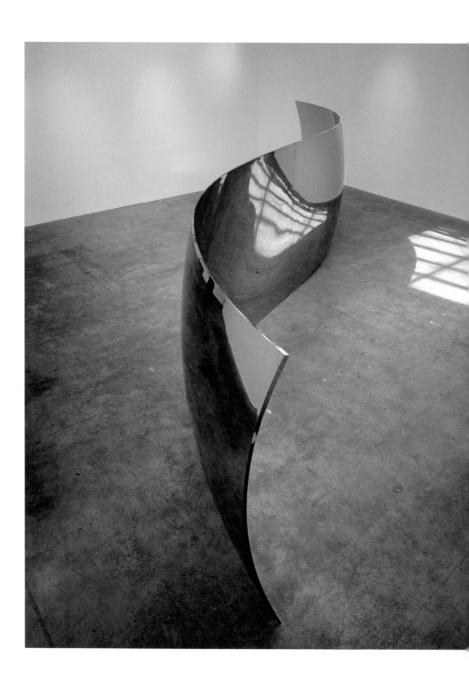

ANISH KAPOOR

S-Curve, 2006

Marsupial, 2006

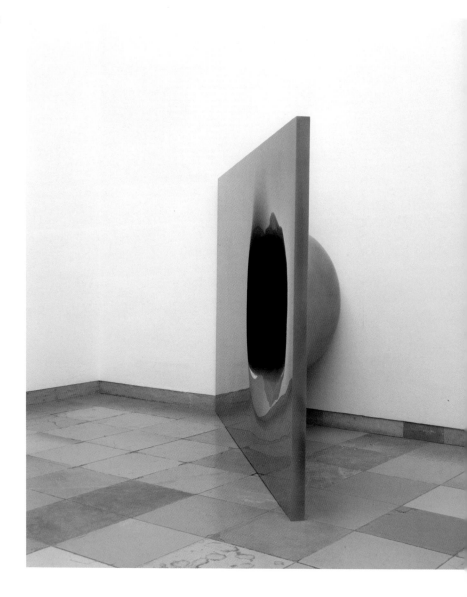

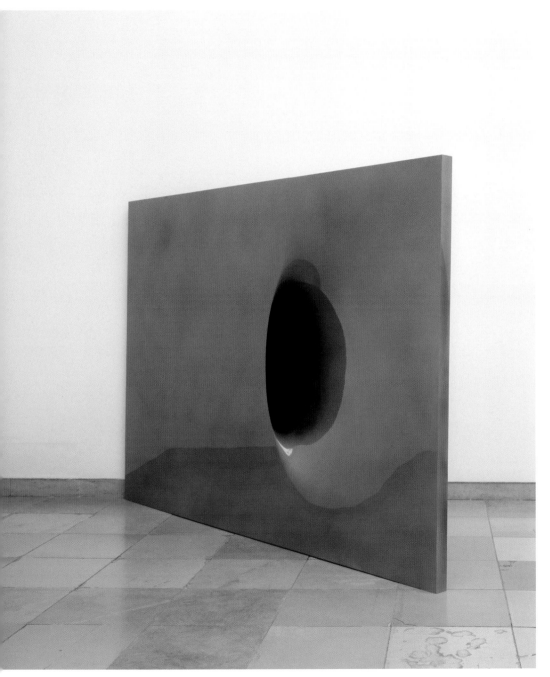

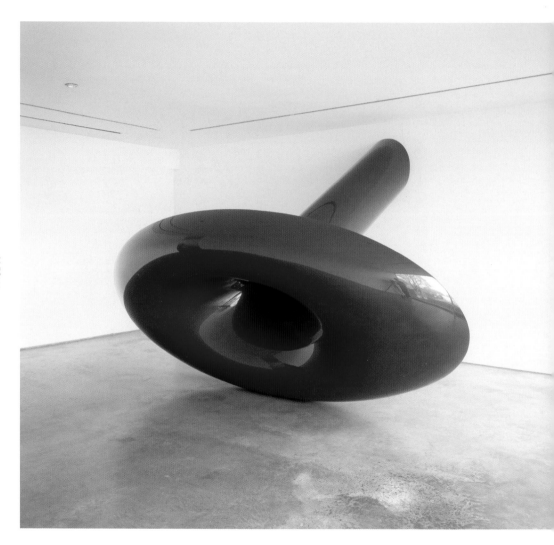

ANISH KAPOOR

Inwendig Volle Figur,
2006

Hexagon Mirror,
2007

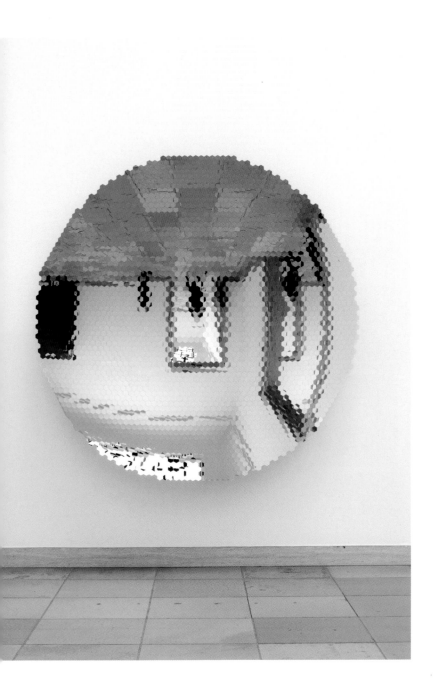

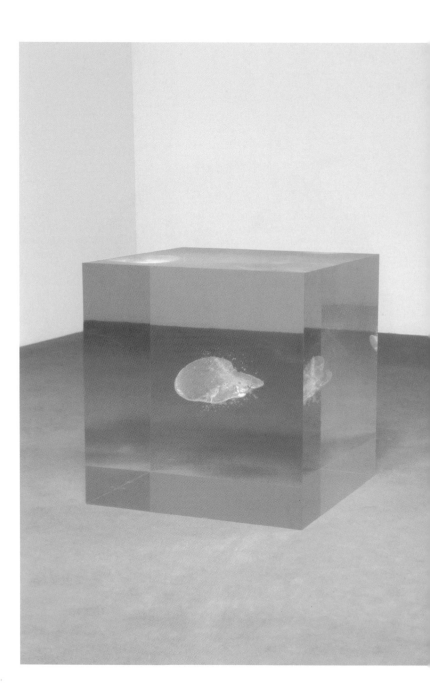

ANISH KAPOOR

TORY, ORY, AND KAPOOR

PARTHA MITTER

Ishi's Light, 2003

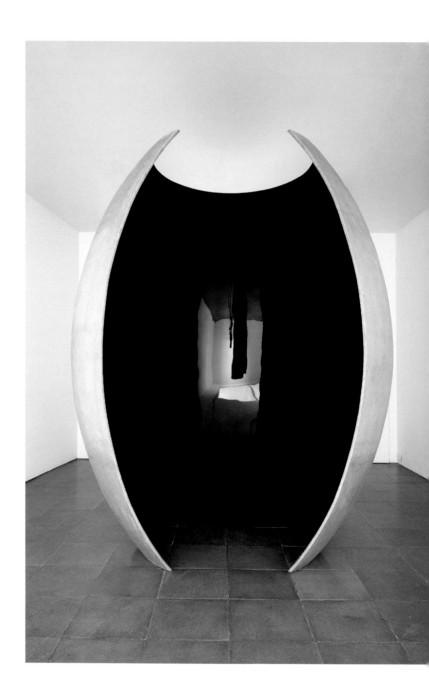

The Tate Modern in London recently honored Anish Kapoor with a special room where his sculptural piece *Ishi's Light* (the title an affectionate reference to his son Ishan) stands face to face in a formalist dialogue with Barnett Newman's two color field paintings. The placement is instructive as it demonstrates Kapoor's method and his singular concentration on a few significant motifs, one might even say tropes. A large slice of the rough-textured, cream-colored, egg-shaped fiberglass structure is cut out, allowing us a glimpse of its highly polished, dark blood-red lacquer interior. Some of Kapoor's recurrent motifs are there: his favorite color, red, and the deeply curved concave mirror that distorts and inverts the familiar visible world—we see our own elongated upside-down images reflected inside the hollow but hardly recognize them; the familiar turns into the Freudian uncanny. In the middle, a streak of light is surrounded by the reflections of the different reds of Newman's paintings opposite.

Not only a conscious affiliation with Barnett Newman, but also the formal language of his object places him firmly within the syntax of late modernism. At the same time, his ambitious site-specific interventions are not what they first seem to be. The unsettled feeling they create in the museumgoer has been described as a form of vertigo or extreme anxiety, faced with an overwhelming presence that arouses fear, awe, and wonder: the stuff of the eighteenth-century aesthetics of the sublime.[1] Suspended from the ceiling, *At the Edge of the World*, 1998, an enormous, deep maroon hemisphere of fiberglass and pigment, engulfs the diminutive spectator on the ground as he experiences this disembodied vision of infinitely silent space. Its simplicity is awe-inspiring, the scale overwhelming. Kapoor's formal inventions and his theoretical sophistication suggest an affinity with the minimalists. He shares with them a concern with the materiality of sculpture, disavowing figuration, inner meaning, and composition, the hallmarks of classical art. He uses processes of fabrication that eliminate any trace of individual craftsmanship, producing works serially that make visible his open-ended creative process. Kapoor's site-specific works also echo Robert Morris's notion of sculpture as "a function of space, light and the viewer's field of vision."

While the surface and material of *At the Edge of the World* attract the viewer, the ultimate effect is the installation's "dematerialized" quality as it floats in an infinite space of pure saturated color. Richard Serra's tough work in industrial metal has also been described as a process of "dematerialization."[2] Yet arguably Kapoor's sculptures offer something more: a sense of ineffable

1— Edmund Burke's *A Philosophical Enquiry into the Origin of Our Ideas of the Sublime and Beautiful* (London, 1757) expounded on the sublime as a different aesthetic experience from the classical notions of beauty; it arouses awe, wonder, and fear, and its scale or the imagined danger associated with it gives a vicarious aesthetic pleasure to the beholder.

2— Hal Foster et al., *Art Since 1900* (London: Thames and Hudson, 2004), pp. 541–542: "A case in point is Richard Serra's *Strike: To Roberta and Rudy*

… a massive steel plate whose dimensions, 8 feet by 24 feet long by 1 inch thick, leave the viewer in no doubt about how much it weighs, but its simplicity both of shape and of construction … could be said to be Minimalist, except that the experience goes beyond this into something else. For the work exists in the contradiction between the threat of its tonnage bearing down on one's body and the sense of its dematerialization into the mere condition of a 'cut'—a line that both separates and connects."

mystery, a fact that has led viewers to find in them a deep nonreligious yet spiritual quest that recalls Newman's meditative color field paintings. Trevor Pateman has seen it as a space for meditation.[3] Kapoor consciously undermines the insistence on the materiality of minimalist sculpture and its spatial literalism. Indeed, he argues that "the history of sculpture may be seen as the history of material. I am making works with the history of the non-material, between illusory and real, between mythology and ordinariness."[4] No wonder he is engaged in exploring myths and symbols that lie deep in the human psyche, which has drawn him to Carl Gustav Jung's theory of the archetype as elaborated in cultural myths. This is not to suggest that his work is either programmatic or dependent on narrative content. Rather, in some

At the Edge of the World, 1998

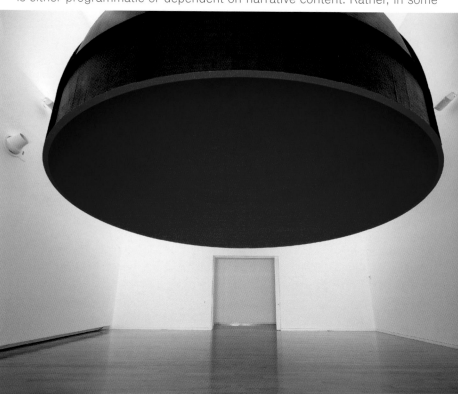

ways the work recalls the predicament of two contradictory elements of modernism, the materiality of a work of art and its opposite, the ideal and the transcendental.

Anish Kapoor represents a postwar phenomenon—that of transnational artists and architects making their mark in the global community. Kapoor born in India, Zaha Hadid born in Iraq, Mona Hatoum born in Lebanon, and earlier

3— Trevor Pateman, "Anish Kapoor at the Hayward Gallery 1998"(incomplete essay, www.selectedworks.co.uk).
4— Ellias, "Nothingness of Being," p. 5.

I. M. Pei born in China—all of them have a high international reputation and all of them work within the modernist and postmodernist paradigm. They are at home in different worlds as they build bridges between the metropolitan center and the periphery. They enrich the rather monolithic modernist canon by offering something unique born of their complex dual or multiple heritages with their layers of heterogeneous history and memory. Kapoor's visionary engagement with his material, his soaring artistic ambition, his extraordinary manipulation of scale from intimate objects to vast alterations of architectural sites, his use of materials from hard-edged polished metal to soft Vaseline, the constant play of paradoxes in his pieces—these elements make his work some of most exciting in the last decades. Formally, he has

Sky Mirror, 2001

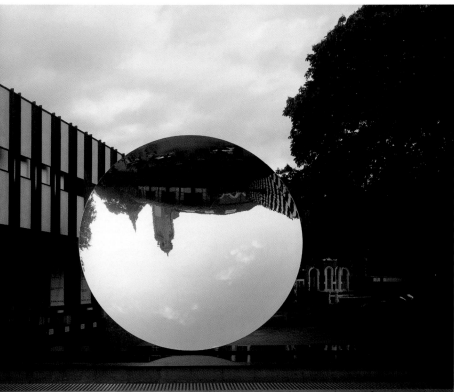

tended to prefer the organic and the curved to the constructivist geometry of modernism. Also, as I have suggested, overriding the materiality of these pieces, spectators have sensed an undefinable transcendental quality that is as moving as it is baffling. This complexity may well be an unintended effect of the colonial legacy of the last two centuries, which created a culture of multiple heritage. The colonized, often as "virtual cosmopolitans," have

had privileged access to knowledge that has been globally disseminated through hegemonic languages such as English, French, and Spanish and through print capitalism. This mixture of culture is further enhanced by large population movements and the emergence of diasporas in the wake of decolonization.[5]

Anish Kapoor was born in India and spent his early life there, moving to London where he trained in art and where he now lives. A thoroughly cosmopolitan child embracing Hindu, Judaic, Iraqi, Islamic, and Indian heritage, he has been claimed by both Britain and India, but let us not forget that he was also invited to design the Holocaust Memorial in Israel. His is a rich mixture of layers of memory and history. Kapoor has spoken of his deep affinities with Indian ideas, and here I would like to explore some of these, with the understanding that Indian resonances in his abstract objects do not imply a one-to-one relationship between Kapoor's art and Indian thought. As I noted, Kapoor works serially, playing with his favorite motifs or metaphors that return with ever-new inflections, modulations, and additional layers of meaning: "color" in its pure essence, described by him as a real thing and non-thing; the dark mystery of the void glimpsed through a precipitous hole; the perceptual ambiguities of convex and concave mirrors with their disturbing interplay of the quotidian and the unfamiliar; various aspects of the body, the taut elastic surface of the skin as a covering for flesh, blood, and viscera; the phallus and the vulva, pregnancy and childbearing.

Let me first take an instance of Kapoor's explicit engagement with history and cultural memory, one that is not related to India but nonetheless helps us to grasp his preoccupations. The Louvre commissioned him to produce a work as part of its project of generating a dialogue between contemporary artists and its sculpture collection. Kapoor chose to install a curved rectangular sheet of polished metal to face the Mesopotamian bas-reliefs in the Khorsabad Court of the museum. His strategic placing of the mirror set up a dialogue between the Mesopotamian bas-reliefs and the modern viewer. On the convex side the images could be easily read, while the reliefs on the mirror's concave side transmogrified into unsettling, almost unrecognizable images, thus bringing into play a series of contrasting illusions, according to its curator: appearance and disappearance, falsehood and truth, visible and invisible, splitting and attenuating.[6] Kapoor has presented these juxtapositions also in churches, contrasting the ambient Christian imagery with rough-hewn granite monoliths, often with a small polished dark or light orifice cut into them. Here at the Louvre he explicitly draws on his own cultural memory of Iraq, and also by implication human history. These ancient Mesopotamian reliefs represented for him the power of religion as well as the origin of sculpture and of civilization.

5— Partha Mitter, *The Triumph of Modernism: India's Artists and the Avant-Garde, 1922–1947* (London: Reaktion Books, 2007), pp. 10–13.

6—*Contrepoint au Louvre: De la sculpture,* Connaissance des Arts series (Paris: Musée du Louvre, 2007), p. 19 ("apparition et disparition, mensonge et vérité, visible et invisible, dédoublement et démultiplication").

One particular cultural memory, I believe, has been Kapoor's epiphany: his discovery of the roots of the sacred in the simple roadside shrines dotted all over India. These shrines are the sites of piety for unlettered millions who smear the deity, most often the Goddess, with vermilion. In the process Kapoor became interested in the affective power of raw pigment, which is integral to his series *1000 Names*. The series is formally one of his most innovative as well as evocative. He makes a striking use of powdered pigments and dye—deep crimson, yellow ochre, and cobalt blue—that ooze onto the floor of the exhibition site (thus also underscoring Kapoor's minimalist insistence on dispensing with the base of conventional sculptures). His manipulation of the exhibition space obliterates the distinction between sculpture and architecture by erasing the figure-ground distinction, the

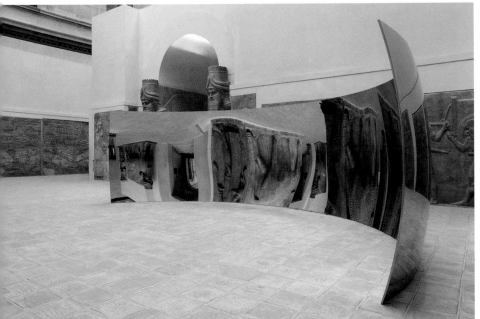

C-Curve, 2007

focus of the installation shifting with the spectator's moving gaze. Kapoor was impressed with the spatial arrangement of the eighteenth-century observatories in northern India called Jantar Mantar. These are some of the earliest observatories in the world, whose astronomical instruments are in fact geometrical structures, namely hemispheres, arcs, cylinders, cubes, and isosceles triangles placed strategically on the ground.[7] Many of the forms of the *1000 Names* are also invocations of religious memory—the Buddhist stupa, the Mesopotamian ziggurat, the ceremonial steps to the Aztec pyramids and to mosques at Samarra. Strikingly, other references include the multiple breasts of the so-called Diana of Ephesus, a celebrated image from

7—Ellias, "Nothingness of Being," p. 6.

ancient western Asia, but which suggests Kapoor's own declared "affinities" with the feminine. Not least, the title *1000 Names* recalls the legend of the thousand names of Vishnu, the great transcendental deity of the Bhagavad Gita, whose epiphanic cosmic image, Vishvarupa, has long exercised the imagination of Indian painters.

Of the array of colors in Kapoor's repertoire, I shall only take two, red and blue, which for the artist are the most replete with symbolism. The color red has been a particular favorite of his. He has spoken of the earthy and physical as well as dreamlike and metaphysical attributes of the color, as in *At the Edge of the World* or *Ishi's Light*. The earthy red dye and the dry pigment that he deploys are redolent of cultural meaning in India. Red in Indian languages, as in Russian, is an attribute of the beautiful,

Entrance to Elephanta Caves
Elephanta Island, near Mumbai, India

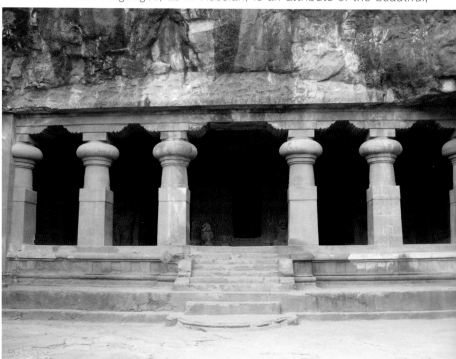

and it is an emotionally charged hue. The vermilion powder made from cinnabar (*sindur*) is worn by married women in India, and Hindu shrines are often washed with red dye in celebration of Devi, Kali, or Durga, manifestations of the Great Goddess, who is associated with blood sacrifice and bodily fluids. Earthy red is associated with messy, organic substance having the consistency of soil and bodily excretions. Closely connected with mother earth, red inspired one of Kapoor's most complex works, *My Red Homeland*, 2003, a steel pestle moving on a circular track by hydraulic

motor at the rate of one revolution per hour, excavating a red Vaseline block weighing some twenty-five tons. The deep red, gooey, organic-looking matter suggests the playful and the erotic but also conjures visions of belonging and alienation, its meaning changing with the context and the site.

Another striking creation in the "red" series is a block made of oil-based paint and three tons of wax that slowly glides on rails. As it makes its lugubrious journey, the block is shaped and reshaped by being forced through arches that are smaller than the block itself. Named *Svayambh*, or self-creating object, it was shown at the Musée des Beaux-Arts in Nantes and the Haus der Kunst in Munich. It is a compelling and sometimes disturbing image, reminding some viewers of the troubled history of the twentieth century, the cattle trucks with their human cargo bound for extermination.[8]

My Red Homeland,
2003 (detail)

Svayambhu is Shiva, the erotic-ascetic, self-creating god who sprang with elemental force out of his own phallus, the Lingodvabha image of the god.[9]

The artist enjoys the vision of a huge block of color as an "object" filling the void of the museum in different stages with its slow movement, leaving traces of its redness as allegories of history and memory as it squeezes through the arches of the museum. It expresses a lot of naughtiness and sexuality as well.[10] The notion of creation without a creator, Nicholas Baume points out, is also the minimalist conceit of art as an impersonal process without the aura

8—Charles Darwent, "Cross the Channel for Sex, Death and Elvis," *The Independent on Sunday*, July 15, 2007, on the exhibition of Anish Kapoor at the Musée des Beaux-Arts, Nantes.
9—Wendy Doniger O'Flaherty, *Siva the Erotic Ascetic* (Oxford: Oxford University Press, 1973).

10— Joanna Moorhead, "Sights: Water Colours," *The Times Knowledge*, July 7, 2007.

of the artist's signature. Yet it is something more than conceptual art, as the object takes on a life of its own. Kapoor is searching for the presence of form in nature, such as the "found" pebbles or polished stones shaped as the *linga* or the *shaligrama shila* (the symbolic form of Vishnu) found beside rivers that are widely worshiped in India.[11] Recalling the Hindu notion of the self-manifest god, Kapoor describes how he allows form to evolve: "Somehow it is not enough that an object is made…it's related to a very old aspect of Indian thinking that there are certain kinds of objects that are self-manifest: they make themselves…their mythology is that they are not made."[12]

Void Field, 1990

Blue is the other resonant color for Kapoor, the deep saturated cobalt blue of infinity, which may be one of the reasons that he admires Yves Klein, who associated this color with the sky, the intangible, and emptiness.[13] In one of Kapoor's creations of the dark abyss of the void glimpsed through a hole in the ground or an orifice in the wall, the whole sense of mystery is heightened by his use of a deep saturated cobalt blue.[14] The void gives the impression of an irresistible force pulling the viewer into its vortex. He has also spoken of the fact that the space within the void is bigger than meets the eye, suggesting the vast space beyond. The imagery surely recalls the concept of the black hole in which the gravitational field is so strong that nothing, not even constellations, can escape once caught.[15] In a conversation with Homi Bhabha, Kapoor speaks of the enigmatic hollows: "The emptiness around things and the conceivable within them collide on reflecting surfaces, besiege the eyes and provoke a disturbing 'unease.'" Bhabha himself added, "A sudden disappearance of surface in

11—Nicholas Baume, "Floating in a Most Peculiar Way," in this publication, p. 25.

12—Anish Kapoor and Donna De Salvo, "A Conversation," in *Anish Kapoor, Marsyas* (London: Tate Publishing 2002), p. 61, quoted in Marina Warner, "The Perforate Self or Nought Is Not Naught," *Parkett*, no. 69 (2003), p. 132.

13—Sidra Stich, *Yves Klein*, exhibition catalogue (Hayward Gallery, London, February 9–April 23, 1995). Kapoor's and Klein's definitions of the void differ in important respects, but there are interesting parallels. Klein was preoccupied with the void as a physical, sensorial, visual, and spiritual phenomenon, which he expressed in monochrome

paintings and austere white rooms and above all in the Theatre of the Void, a joyous manifestation of immateriality with no stage, no actors, no scenery, no narrative, and no spectator (see Stich).

14—Denis Gielen, "The Vertiginous Desire for Native Colours," in *Anish Kapoor: Melancholia*, exhibition catalogue (Musée des Arts Contemporains de la Communauté Française de Belgique au Grand Hornu, October 24, 2004–March 6, 2005), pp. 81–82. International Klein Blue was the phosphorescent blue color patented by Klein.

15—Subrahmanyan Chandrasekhar's most famous success was the astrophysical Chandrasekhar limit. The limit describes the maximum mass (~1.44 solar

a deep, dark hole literally cuts the ground from under our feet."[16] Kapoor speaks of the void not as an empty space but as space with a substance. This has an analogy with the mathematical concept of the nought or *shunya* in ancient Indian mathematics. Shunya, which was most probably invented in ancient India, is not the "absence" of something that you can obtain by subtraction; it is a positive concept.[17] Finally, the void could also be seen as the repository of the numinous, as in the dark hollow of the *garbha griha* (embryo chamber), the sanctum of a Hindu temple, evoking the mother's womb. As opposed to the "manifest" deity in the outside world of men, the presence of the "nonmanifest" deity can only be felt by the devotee in the

dark recesses of the garbha griha.[18] Kapoor's sculptural projects set up an uneasy relationship between the material and the nonmaterial. He has spoken of his concave mirrors arousing a feeling of "immateriality," and the dialectic between form and formlessness has been an abiding concern for him. In ancient Indian thought, nonmateriality goes back to the philosophical system of the Upanishads, which Malevich had sought to express in his suprematism.[19] This dialectic in Kapoor also yields itself to mathematical analysis. His objective has been to disrupt the straight relationship between the surface of the sculpture and its mass that may disclose its volume and substance. In *Marsyas* the pliability and elasticity of the membrane is a metonym for skin, and here it is stretched by steel the way the mythical *Marsyas* was stretched out to be flayed on Apollo's orders. A gigantic engineering construction made of PVC membrane supported by a steel structure, pervading the whole of the

Pillar, 2003

masses) of a white dwarf star, or equivalently, the minimum mass for which a star will ultimately collapse into a neutron star or black hole following a supernova. See Wikipedia for his biography and S. Chandrasekhar, *The Mathematical Theory of Black Holes* (New York: Oxford University Press, 1983).

16—*Anish Kapoor*, catalogue of the exhibition at the Hayward Gallery, London, 1998, with essays by Homi K. Bhabha and Pier Luigi Tazzi (Berkeley: University of California Press, 1998).

17—See A. L. Basham, *The Wonder that Was India* (London: Sidgwick and Jackson, 1954), pp. 495–496.

18—Interestingly, at Elephanta the great three-faced Maheshamurti figure represents Shiva as both manifest and nonmanifest deity.

19—On Malevich and Indian philosophy, see David Pan, *The Primitive Renaissance* (Lincoln: University of Nebraska Press, 2001), pp. 102–120; Maurice Tuchman, *The Spiritual in Art: Abstract Painting, 1890–1985*, catalogue of an exhibition at Los Angeles County Museum of Art (New York: Abbeville Press, 1986).

atriumlike Turbine Hall of the Tate Modern, *Marsyas* changes shape from floor to floor according to the beholder's perspective and field of vision. In the same way that Kapoor's holes in the ground or the wall create a sense of space that cannot be visualized with the naked eye, or that he opens up deep space in *At the Edge of the World*, so the trumpetlike *Marsyas* cannot be visualized as a whole from a fixed viewpoint, its form changing with the shifting gaze. Cecil Balmond has applied computer-generated mathematical models at a laboratory of contemporary architecture in London

Melancholia,
2004

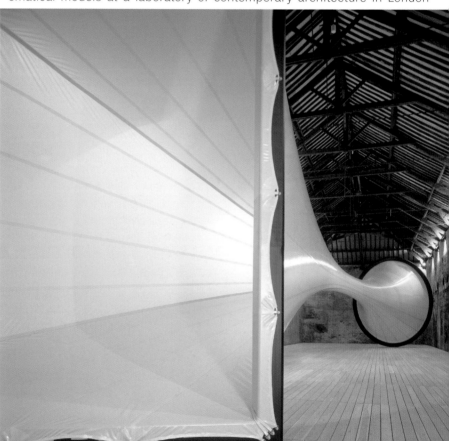

to calculate the differing algorithms of the shifts in the form of Kapoor's towering objects.[20] The overall idea that comes across is the dissolution of the works' material form.

Anish Kapoor reminds us of Barnett Newman's stricture that scale is not a matter of size but of content. Kapoor's scale is dependent also on the careful deployment of relative proportions. Thus, as in the stone

20—Kurt W. Forster, "A Word Is the Giant's Ear,"
Parkett, no. 69 (2003), p. 122.

sculpture-like structures of ancient India, especially the great carved monolith known as the Kailasa Temple to Shiva at Ellora, the actual impression of overwhelming monumentality is dependent less on the actual size than on the manipulation of proportions and space. This raises an important aspect of Kapoor's work, his mathematical and geometrical imagination that enriches his sculptures. Sometimes he uses a mathematical curve generation system to analyze his drawings, and he is known to have used fractals in *1000 Names*.[21] The complex geometry of the elevations of the north Indian temples, as for instance at Khajuraho, shows that Hindu designers developed a system that can be best explained by the concept of "self-imaging" developed by modern chaos theory. These so-called fractals are "self-same" in that they will be the same on every scale. Many of the greatest Hindu architects develop this geometric principle of nature with remarkable virtuosity.[22] In *Melancholia*, which makes use of PVC membrane, Kapoor works with two elementary geometric forms, a circle and a square, and it is "impossible to say whether

the circle sits within the square or, conversely, the square within the circle... even if we measure them and discover that the circle's diameter is equal to the side of the square."[23] A team of engineers worked on *Melancholia* to calculate its gradual transition from square to circle. However, as Laurent Busine comments, Kapoor's own ideas are at play here: the form passes from circle to square, but we view it from our standpoint and each form envelops the other as if covered by its skin. He also points out that the four bodily humors (of which melancholy is one) are related to geometry and the science of space and mathematics in medieval thought. In fact strict mathematics and geometry have been integral to the construction principles of the Hindu temple, in which sculpture and architecture form part of the sacred decoration. The whole of Hindu sacred architecture can be reduced to the geometry of the square and the circle, as we see from the segments of the temple elevations produced out of the square within the circle. Indeed, as has been shown, entire temples were determined by squares turned within circumscribed circles. I do not want to be misunderstood here. Visually there are no

Kailasa Temple, Ellora, India

21—Gielen, "The Vertiginous Desire for Native Colours," p. 83. The author's view that Kapoor uses the curve generation system to draw is not quite accurate.

22—Partha Mitter, *Indian Art* (Oxford: Oxford University Press, 2002), p. 24.

23—Laurent Busine, in *Anish Kapoor: Melancholia*, p. 73.

PAGE 118

similarities between Kapoor's abstract works and the figurative imagination in Hindu temples. The affinity, I would suggest, lies in the underlying principles of construction.

With its different and sometimes contradictory elements, Kapoor's work thrives on *coincidentia oppositorum*, the coexistence opposites. He explores metaphysical polarities: presence and absence; being and nothingness; place and nonplace; the solid and the intangible; objective and nonobjective. His approach has resonance with Samkhya, the ancient Indian dualist philosophy and its belief in the two constant polarities in the universe, *prakriti* (material essence) and *purusha* (consciousness). The duality of Kapoor's corpus is the implicit tension between his formalist imagination and an engagement with deep metaphysical elements of Indian philosophy that exist as different layers in his sculptures. He explores contradictions and paradoxes, seeing them as part of the human condition. The convex and concave shapes of the curved mirror play on materiality/ immateriality (world upside down and inside out). The very notion of "immateriality" can be traced back to the ancient Indian philosophical texts, the Upanishads, which speak of the "delusion" of believing in the stability of the material universe.[24] To return to Kapoor's set of binaries: the manichaean contrast of the effulgent light reflected in the polished mirror,"the world inside out," versus the dark abyss glimpsed through the crack in the floor or the wall; male and female; earth-sky; matter-spirit; visible-invisible; conscious-unconscious; mind-body. In short, the most important thing about Kapoor's work is its dense texture of multiple meanings as his work takes on a particular significance according to where it is sited, expressing a constantly changing, almost protean quality. His brightly colored illuminated exterior turns on itself to become a gaping black hole that irresistibly draws you into its lightless chasm, his intimate treatment of well-crafted metal contradicts his vast ambitious manipulation of spaces, and his gendered imagery of the interpenetration of the feminine and the masculine offers the viewer an intimate play of forms and colors. Viewers have been moved by the intangible spiritual content of the artist's constructions, in monumental as well as small-scale works, as they have been attracted to the elegant surface of his constructions and impressed with his ability to solve large problems of design and construction. What remains is a powerful dualist set of binaries that are balanced on a knife's edge. These do not achieve resolution, as they are not meant to, since the tension between materiality and transcendence is one of the great predicaments of contemporary art. The unique contribution of Anish Kapoor lies in the way he has used these binaries to consistently expand the language of art in new and unexpected directions.

24—For a useful introduction to the Upanishads, see R. A. Hume, trans., *Thirteen Principal Upanishads* (Oxford: Oxford University Press, 1921).

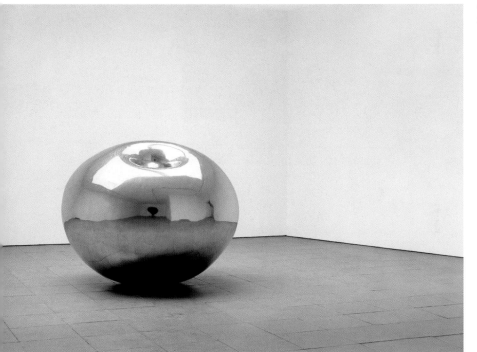

*Turning the World
Inside Out,* 1995

BEING

CLOU

MARY JANE JACOB

G WITH
D GATE

MARY JANE JACOB

All images *Cloud Gate*, 2004

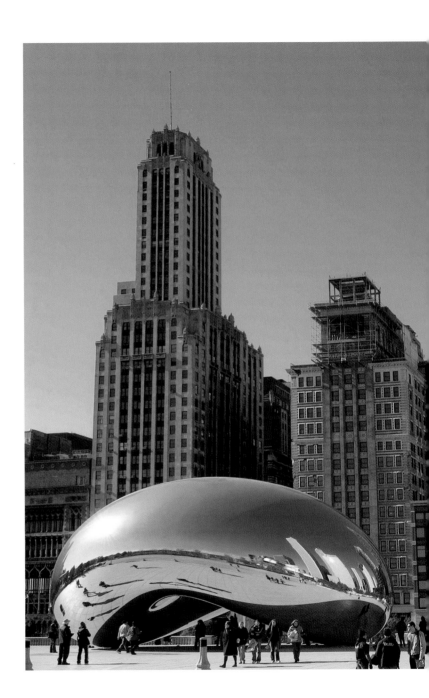

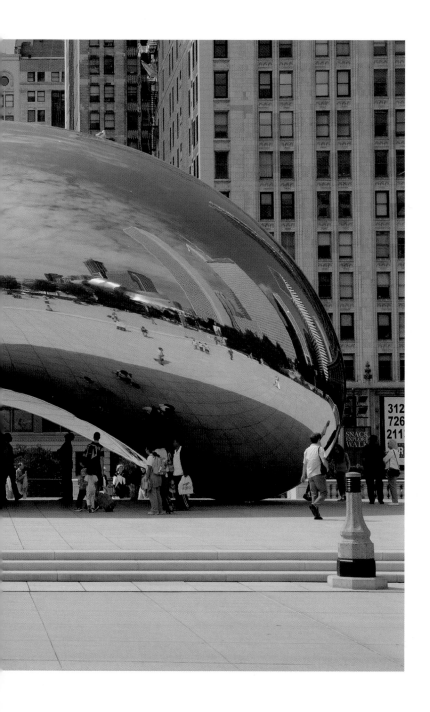

MARY JANE JACOB

are contained within Kali and can be found in other aspects of Hindu and Buddhist culture. "Complementary cosmic forces creating and sustaining the universe through their essential and intimate interaction," in Kapoor's words. Fundamental polarities of Hindu metaphysics are part of the culture, and are tensions in balance or multiple aspects to draw upon in achieving the whole: "The One Center divides into two modes of expression that together initiate a process of change through history. The experience of opposites allows for the expression of wholeness." In Indian culture, among the primal dualities that are one are the lingam and yoni. Male and female in one entity, two faces or dispositions of the same, *Cloud Gate* is at once vagina and testicles—both containers of creative forces. Neither one nor the other but both. Like much of Kapoor's work, it constitutes a third space: in between, not inside or outside but both, and without boundaries.

At the point of origin and seat of creativity lies infinite potentiality. Non-form allows multiple and infinite views; not fixing us in a point of perception we have had before means great possibility, the chance to see anew as if for the first time, the way to see beyond and deeper as if we had wisdom of the ages. Indeed we do, within intuition. Buddhism calls this "empty space." Kapoor says, "The more I empty out, the more there is. Emptying out is filling up." So while we see ourselves in *Cloud Gate* as in a mirror, as we can perceive the fleetingness of time and ourselves within this enfolding, the march to death is exchanged for the potential of eternity. At the point of origin, in the center of the work, in the great opening or womb we see ourselves and others go on forever, unending, enduring into infinity. "You cannot enter the void, but viewing gives prospect to the wholeness it contains."

Thus, *Cloud Gate* enables a dual state of reflection, offering a way for levels of experience. This first occurs by showing us our outward appearance and that of others—a superficial or transitory state captured for a moment in its mirrored surface. No wonder people are initially compelled, drawn, to capture themselves and their friends and loved ones, to halt time however briefly, to be eternal. Then there is the longer or second look. Upon reflection, using this work as a vehicle or devotional object of practice, deeper thought can be cultivated. It becomes "a gateway to eternity." *Cloud Gate* is about self and beyond self. "I think about the kind of space that there might be in an image of a meditating Buddha, where all attention is focused inward," Kapoor has said.

In this infinite space and time, we can also see reflected a complex unity. Indra's net is a Buddhist model for concepts of the infinite interconnectedness of the universe as one of emptiness or potentiality and codependence. "Indra's net symbolizes a universe where infinitely repeated mutual relations exist between all members of the universe."[7] Also called the jewel net of

7—"The metaphor of Indra's net was developed by the Mahayana Buddhist school in the 3rd century scriptures of the Avatamsaka Sutra, and later by the Chinese Huayan school between the 6th and 8th century. Buddhist concepts of interpenetration hold that all phenomena are intimately connected." See http://en.wikipedia.org/wiki/Indra's_net

MARY JANE JACOB

Indra, it is visualized as a web of connections between uniquely multifaceted jewels positioned at each vertex. In each jewel is reflected the whole; as one part moves, all are affected and respond. *Cloud Gate*'s jewel-like surface has many jewels reflected in it, many beings in relation to each other.

Does the public have this experience? Yes, on multiple levels and over time. John Dewey wrote: "In order to understand the meaning of artistic products, we have to forget them for a time, to turn aside from them and have recourse to the ordinary forces and conditions of experience that we do not usually regard as esthetic."[8] Dewey was speaking of art in general. The reflection on art experience that he evokes, triggered by life's occurrences, can link back to works we have seen anywhere and anytime—in cities or in nature, in the space of a gallery or open space. Yet how we come to know a work of art, how it seeps into our consciousness, what references it accrues, and which moments in our lives it figures into, vary greatly. For those who do not have occasion to walk into, say, the adjacent Art Institute of Chicago or do not imagine themselves frequenting a museum, for those who go to the museum's galleries on occasion but are every day on the city streets, Kapoor's work affords many more opportunities for exchange and encounter. In just the short time it has existed here, it has come to occupy multiple memories of many of us already. It is a collective experience, too. Thus, it is all the more important that *Cloud Gate* is a public work: a work that we can easily revisit over time and that revisits us as we go about life. It is a new center of the city and a center from which we gain energy.

This mirror that Kapoor has given us is not so much a mirror of the self or of the city as a mirror into the self and in which we can see ourselves in union with others. As individuals and together, we are a constantly changing landscape. Hence the very notion of a reflection of our image or of the city's skyline, capturing a moment or enduring image, is outside the realm of the real. *Cloud Gate* provides proof of this through the palpable experience of energy-in-flux it affords, giving us a way to see the transience and fleetingness of our life and that of others. In doing so, what it does reflect is beyond self and place and is located in an understanding—whether on a level of conscious cognition or intuitive knowledge—gleaned through its presence in everyday circumstances. So while the material in its making and this place in the work's siting have been transformed, it is our own experience that undergoes the greatest transformation. And such an "act of transformation," according to Kapoor, "is the same as an act of prayer, consecrating a particular time which is separated from one's ordinary life."

8— Dewey, *Art as Experience*, p. 2.

CHRONOLOGY

Born 1954 in Bombay, India
Lives and works in London

1977–78
Chelsea School of Art, London

1990
Awarded Premio Duemila at the Venice Biennale

1991
Turner Prize Award

1997
Awarded Honorary Doctorate at the
London Institute

2001
Awarded an Honorary Fellowship at
Royal Institute of British Architecture

2003
Awarded CBE

SELECTED SOLO EXHIBITIONS

1980
Patrice Alexandre, Paris

1982
Lisson Gallery, London

1984
Gladstone Gallery, New York

1985
Kunsthalle, Basel (exh cat) (traveled to Stedelijk
Van Abbemuseum, Eindhoven)

Currents, Institute of Contemporary
Art, Boston (exh cat)

1986
Kunstnernes Hus, Oslo (exh cat)

Gladstone Gallery, New York

Anish Kapoor: Recent Sculpture and Drawings,
University Gallery, Fine Arts Center, University
of Massachusetts, Amherst (exh cat)

1990
*Anish Kapoor, XLIV Biennale di
Venezia*, British Pavilion, Venice (orga-
nized by The British Council)

1990–91
Anish Kapoor Drawings, Tate
Gallery, London (exh cat)

Le Magasin, Centre National d'Art
Contemporain, Grenoble, France

1991
Palacio de Velázquez, Centro de Arte
Reina Sofía, Madrid (exh cat) (organized in
cooperation with The British Council)

1992–93
San Diego Museum of Contemporary Art,
La Jolla, California (exh cat) (traveled to the
Des Moines Art Center, Des Moines, Iowa;
The National Gallery of Canada, Ottawa;
The Power Plant, Toronto)

1993
Tel Aviv Museum of Art, Tel Aviv, Israel (exh cat)

Gladstone Gallery, New York

1994
Echo, Kohji Ogura Gallery, Nagoya, Japan

1995
Lisson Gallery, London

1996
Galleria Massimo Minini, Brescia, Italy

1998
Gladstone Gallery, New York

Hayward Gallery, London

1999
SCAI The Bathhouse, Tokyo, Japan

CAPC Musée d'Art Contemporain
de Bordeaux, Bordeaux, France

2000
Blood, Lisson Gallery, London

The Edge of the World, permanent installation at
Axel Vervoordt Kanal, Wijnegem, Belgium

Blood Solid, fig-1, London

Taratantara, installation, BALTIC Centre
for Contemporary Art, Gateshead, UK
and Piazza del Plebiscito, Naples, Italy

2001
Taidehalli, Helsinki, Finland

Gladstone Gallery, New York

2002
Marsyas, 3rd Unilever Commission for the
Turbine Hall, Tate Modern, London

2003
Painting, Lisson Gallery, London

Kukje Gallery, Seoul, Korea

Galleria Continua, San Gimignano, Italy

Idomeneo, Glyndebourne, East Sussex, UK
(set design)

My Red Homeland, Kunsthaus Bregenz,
Bregenz, Austria

National Archaeological Museum, Naples, Italy

2004
Whiteout, Gladstone Gallery, New York

Cloud Gate, Millennium Park, Chicago

Anish Kapoor, Massimo Minini Gallery,
Brescia, Italy

Melancholia, MAC Grand-Hornu, Hornu, Belgium

2005
Japanese Mirrors, SCAI The Bathhouse,
Tokyo, Japan

2006
My Red Homeland, CAC Málaga, Málaga, Spain

Anish Kapoor, Regen Projects, Los Angeles

Anish Kapoor: Ascension, BBCC, Rio de Janeiro, Brazil (traveled to Brasília and São Paulo, Brazil)

Sky Mirror, Rockefeller Center, Public Art Fund, New York

Anish Kapoor, Lisson Gallery, London

2007
Anish Kapoor: Works on Paper, Gladstone Gallery, New York

Anish Kapoor—Svayambh, Musée des Beaux-Arts, Nantes, France

Anish Kapoor, Galleria Continua, Beijing

Anish Kapoor—Svayambh, Haus der Kunst, Munich

2008
Anish Kapoor, Gladstone Gallery, New York

SELECTED GROUP EXHIBITIONS
1975
Young Contemporaries, Royal Academy of Art, London

1979
Whitechapel Open, Whitechapel Art Gallery, London

1981
Institute of Contemporary Art, London (exh cat) (traveled to Arnolfini Gallery, Bristol, UK)

1982
Objects and Figures: New Sculpture in Britain, Fruitmarket Gallery, Edinburgh (exh cat) (organized by the Scottish Arts Council)

1983
The Sculpture Show, Hayward Gallery/Serpentine Gallery, London (exh cat) (organized by the Arts Council of Great Britain)

1984
An International Survey of Recent Painting and Sculpture, Museum of Modern Art, New York (exh cat)

1985
20 Sculptures du FRAC Rhône-Alpes, l'Abbaye de Tournus, Tournus, France

1986
Vessel, Serpentine Gallery, London

1987–88
Viewpoint. L'Art Contemporain en Grande Bretagne, Musée d'Art Moderne, Brussels (exh cat) (organized in cooperation with the British Council)

1988
Britannica. 30 Ans de Sculpture, Musée des Beaux-Arts André Malraux, Le Havre; Ecole d'Architecture de Normandie, Rouen; Musée d'Evreux, Evreux

1988–89
Carnegie International, Carnegie Museum of Art, Pittsburgh, Pennsylvania

1990
British Art Now: A Subjective View, (exh cat) (organized by the British Council) (traveled to Setagaya Museum, Tokyo; Fukuoka Art Museum, Fukuoka, Japan; Nagoya City Museum, Nagoya, Japan; Tochigi Prefectural Museum of Fine Arts, Tochigi, Japan; Hyogo Prefectural Museum, Hyogo, Japan; Hiroshima City Museum, Hiroshima)

1991
Turner Prize 1991: An Exhibition of Work by the Four Shortlisted Artists, Tate Gallery, London (exh cat)

1992
Documenta IX, Kassel, Germany

1992–93
Stedelijk Museum, Amsterdam

1996
Britische Kunst an der Unterelbe, Stade, Germany (exh cat)

1998
Towards Sculpture, Fundação Calouste Gulbenkian, Lisbon (exh cat)

1998
Then and Now, Lisson Gallery, London

1999
Beauty—25th Anniversary, Hirshhorn Museum and Sculpture Garden, Washington, D.C. (exh cat: *Regarding Beauty*) (traveled to Haus der Kunst, Munich)

2000
La Beauté, Papal Palace, Avignon, France

Drawings 2000, Gladstone Gallery, New York

2001
1951–2001 Made in Italy, Triennale, Palazzo dell'Arte, Milan

Bo01, Concepthaus, Malmö, Sweden

Drawings, Regen Projects, Los Angeles

Field Day: Sculpture from Britain, Taipei Fine Arts Museum, Taipei, Taiwan (exh cat) (organized by the Taipei Fine Arts Museum and the British Council)

2002

Homage to Rudolf Schwarzkogler, Galerie Krinzinger, Vienna, Austria

Kaash, Anish Kapoor, Akram Khan, Nitin Sawhney (touring collaborative dance production, premier March 28, Paris)

this ain't no tupperware, Kunststof(f), Kortrijk and Herford, Begium

Colour White, De La Warr Pavilion, East Sussex, UK

Remarks on Colour, Sean Kelly Gallery, New York

Blast to Freeze, Kunstmuseum Wolfsburg, Germany

Retrospectacle: 25 Years of Collecting Modern and Contemporary Art, Denver Art Museum, Denver, Colorado

2003

Mind Space, Ho-Am Art Gallery, Seoul, Korea (works in the collection of the Samsung Museum of Modern Art)

Beaufort 2003, Ostend, Belgium

Himmelschwer, Graz, Austria (traveled to Odense, Denmark)

Ineffable Beauty, Kunsthalle Erfurt, Germany

In Good Form: Recent Sculpture from the Arts Council Collection, Longside Gallery, Yorkshire Sculpture Park, Wakefield, UK

Minimalism and More: Contemporary Art from the Frederick R.. Weisman Art Foundation, Frederick R. Weisman Museum of Art, Minneapolis, Minnesota

Saved! 100 Years of the National Art Collections Fund, Hayward Gallery, London

2004

*Pain: Passion, Compassion, Sensibility, Science Museum, London

Lustwarande 04, Tilburg, The Netherlands

Gwangju Biennale, Korea

Arts and Architecture 1900–2000, Palazzo Ducale, Genoa, Italy

Kanazawa Museum, Kanazawa City, Japan

2005

Universal Experience, Museum of Contemporary Art, Chicago

Colour after Klein, Barbican Art Gallery, London

British Sculpture Show, Kunsthalle Würth, Künzelsau-Gaisbach, Germany

God Is Great, Venice

Museo Madre, Naples, Italy (site-specific installation)

Arte all'Arte, San Gimignano, Italy

2006

Sixty Years of Sculpture in the Arts Council Collection, Yorkshire Sculpture Park, Wakefield, UK

The Sublime Is Now, Museum Franz Gertsch, Burgdorf, Switzerland

Sculpture, Thaddaeus Ropac, Salzburg, Austria

The Expanded Eye, Kunsthaus Zurich, Switzerland

Surprise, Surprise, Institute of Contemporary Art, London

How to Improve the World, Hayward Gallery, London

Asia Pacific Triennial of Contemporary Art, Queensland Art Gallery, South Brisbane, Australia

Super Vision, Institute of Contemporary Art, Boston

2007

One Colour, Galleria Continua, Beijing

Timer, Milan

Contrepoint III, Louvre, Paris

Artempo, Palazzo Fortuny, Venice

Makers and Modelers, Gladstone Gallery, New York

SELECTED BIBLIOGRAPHY: BOOKS AND CATALOGUES

1982

British Sculpture Now. Kunstmuseum, Luzern, Switzerland (exh cat). Text by Michael Newman.

1983

Anish Kapoor. Beeldhouwwerken. Galerie 't Venster, Rotterdam (organized by Rotterdam Arts Council) (exh cat). Text by Michael Newman.

Anish Kapoor. Kunsthalle, Basel (exh cat). Texts by Jean-Christophe Ammann, Alexander von Grevenstein, and Ananda Coomaraswamy.

1986

Anish Kapoor. Kunstnernes Hus, Oslo (exh cat). Texts by Arne Malmedal and Lynne Cooke.

Anish Kapoor: Recent Sculpture and Drawings. University Gallery, Fine Arts Center, University of Massachusetts, Amherst (exh cat). Text by Helaine Posner.

Anish Kapoor. Albright-Knox Art Gallery, Buffalo, New York (exh cat). Text by Helen Raye.

1987
A Quiet Revolution: British Sculpture since 1965. Museum of Contemporary Art, Chicago, and San Francisco Museum of Modern Art (exh cat). Text by Lynne Cooke.

Anish Kapoor: Works on Paper 1975–1987. Ray Hughes Gallery, Brisbane, Australia (exh cat). Interview by Richard Cork.

1989
Anish Kapoor. Kohji Ogura Gallery, Nagoya, Japan, in cooperation with Lisson Gallery, London (exh cat). Text by Pier Luigi Tazzi.

1990
Anish Kapoor. British Pavilion, XLIV Venice Biennale. The British Council, London (exh cat). Texts by Thomas McEvilley and Marjorie Allthorpe-Guyton.

Anish Kapoor. Art Random, Kyoto Shoin International, Kyoto, Japan. Edited by Marco Livingstone.

Anish Kapoor: Drawings. Tate Gallery, London (exh cat). Text by Jeremy Lewison.

Dujourie, Fortuyn, Houshiary, Kapoor. Rijksmuseum, Amsterdam. Kröller-Müller, Otterlo (exh cat). Text by Marianne Brouwer.

1991
Anish Kapoor. Centro de Arte Reina Sofía, Madrid and The British Council (Spanish edition of XLIV Venice Biennale exh cat).

Anish Kapoor & Ban Chiang. Feuerle, Cologne (exh cat). Text by Angel García.

Anish Kapoor. Kunstverein Hannover and The British Council (exh cat).

The Turner Prize 1991. Tate Gallery, London (exh cat). Text by Sean Rainbird.

1992
Anish Kapoor. Galeria Soledad Lorenzo, Madrid (exh cat). Text by José-Miguel Ullán.

1995
Anish Kapoor. De Pont Foundation, Tilburg, The Netherlands (exh cat).

Germano Celant, *Anish Kapoor*. Milan: Charta.

1996
Britische Kunst an der Unterelbe. Stade, Germany (exh cat). Texts by Eckhard Schneider, Antony Gormley, Heidi Kwastek, Ulrike Schuck, Marc Quinn, Hans-Georg Schröder, Tim Marlow, Hans-Eckhard Dannenberg, Beate-Christine Fiedler, Dieter-Theodor Bohlmann, James Hall, Gerd Mettjes, Stephan Berg, Gerd Meier Linnert, Bettina Roggmann, Susanne Mayerhofer, and Klaus Frerichs.

1998
Anish Kapoor. Hayward Gallery (exh cat). Texts by Homi Bhabha and Pier Luigi Tazzi.

Towards Sculpture. Fundação Calouste Gulbenkian, Lisbon. (exh cat). Text by Rui Sanchez.

2000
Taratantara. BALTIC Centre for Contemporary Art, Gateshead, UK (exh cat).

2001
Taratantara. Naples (exh cat). Texts by Eduardo Cicelyn and Mario Codognato. (exh cat).

Anish Kapoor. Kunsthalle Helsinki (exh cat). Text by Michael Tarantino.

2002
Anish Kapoor: Marsyas. Tate Publishing (exh cat). Texts by Donna de Salvo and Cecil Balmond.

2003
Anish Kapoor. National Archaeological Museum, Naples (exh cat). Texts by Eduardo Cicelyn and Mario Codognato.

Anish Kapoor: My Red Homeland. Kunsthaus Bregenz (exh cat). Texts by Eckhard Schneider, Thomas Zaunschirm, and Yehuda E. Safran.

2004
"Anish Kapoor, Francis Alys, Isa Genzken." *Parkett*, no. 69. Texts by Norman Bryson, Marina Warner, and Kurt Forster.

Anish Kapoor: Whiteout. Gladstone Gallery, New York (exh cat). Published by Charta. Text by Anthony Vidler.

Anish Kapoor: Melancholia. MAC Grand-Hornu (exh cat). Texts by Laurent Busine and Denis Gielen.

2005
Anish Kapoor: Drawings. Published by Verlag der Buchhandlung Walther König, Cologne. Texts by Jeremy Lewison and Laurent Busine.

2006
Anish Kapoor: My Red Homeland. CAC Málaga (exh cat). Texts by Fernando Frances and Angela Molina.

Super Vision. Institute of Contemporary Art, Boston (exh cat). Texts by Nicholas Baume, David Joselit, and McKenzie Wark.

PHOTO CREDITS

All Anish Kapoor images courtesy the artist and Lisson Gallery, unless otherwise noted

Cover, endpapers
Courtesy the City of Chicago and Gladstone Gallery, New York
Photo: Nicholas Baume

pp. 14, 70
Photo: John Riddy, London

p. 16
Photo: Dave Morgan, London

pp. 17, 94-95
Photo: Dave Morgan, London

pp. 18, 122, 125, 127, 128, 133
Courtesy the City of Chicago and Gladstone Gallery, New York
Photo: Patrick Pyszka, City of Chicago

p. 18
Photo: Nic Tenwiggenhorn
©VG Bild-Kunst, Bonn, 2003

pp. 19, 68-69
Photo: Nic Tenwiggenhorn
©VG Bild-Kunst, Bonn 2003

p. 20
Photo: Andrew Penketh, London

p. 21
Courtesy Tate, London
Photo: John Riddy, London

p. 22
Photo: Richard Ashworth / Getty Images

p. 23
Photo: Hirosuke Yagi, Nagoya

pp. 24, 91
Photo: Dave Morgan, London

pp. 24, 100
Photo: Dave Morgan, London

p. 25
Courtesy the artist and the Paula Cooper Gallery, New York

pp. 27, 92
Courtesy Regen Projects, Los Angeles
Photo: Joshua White, Los Angeles

p. 30
Photo: Ray Fulton

p. 31
Clore Collection, Tate Gallery, London / Art Resource, New York

p. 32
Courtesy Alexander and Bonin, New York

p. 32
© 2008 Artists Rights Society (ARS), New York / VG Bild-Kunst, Bonn

p. 33
Photo: Glowimages / Getty Images

pp. 35, 113
Courtesy Kunsthaus Bregenz, Gladstone Gallery, New York, and Lisson Gallery
Photo: Nic Tenwiggenhorn, Kunsthaus Bregenz

p. 35
Photo: Wilfried Petzi, Munich

p. 37
Photo: Dave Morgan, London

p. 39
Photograph © 2008 Museum of Fine Arts, Boston

p. 42
Photo: Dave Morgan, London

p. 43
Photo: Nicholas Baume

p. 44
Photo: Gareth Winters, London

p. 46
Photo: Florian Holzherr, 2002

p. 49
Photo: Dirk de Neef, Ghent

p. 51
Photo: Frederic Delpech, 1999

p. 53
CNAC / MNAM / Dist. Réunion des Musées Nationaux / Art Resource, New York
Photo: Adam Rzepka
© 2008 Artists Rights Society (ARS), New York / ADAGP, Paris

p. 53
Courtesy Tate, London
Photo: Marcus Leith and Andrew Dunkley

p. 55
Photo: Wilfried Petzi, Munich

p. 64
Photo: Larry Lame, New York

p. 66
Photo: Robert Hasser, Mannheim

p. 73
Photo: Attilio Maranzano, Sienna

p. 74
Photo: © Frederic Delpech, 1999

p. 77
Photo: John Riddy, London

p. 78
Photo: John Riddy, London

p. 81
Photo: Dave Morgan, London

p. 82-83
Courtesy Lisson Gallery and Gladstone Gallery, New York
Photo: Jussi Tianen, Helsinki

p. 84
Photo: John Riddy, London

p. 87
Photo: Nic Tenwiggenhorn
©VG Bild-Kunst, Bonn, 2003

p. 88
Photo: Wilfried Petzi, Munich

p. 96
Photo: Dave Morgan, London

p. 99
Photo: Wilfried Petzi, Munich

p. 103
Photo: Wilfried Petzi, Munich

p. 106
Photo: Dave Morgan, London

p. 108
Photo: John Riddy, London

p. 109
Photo: Dave Morgan, London

p. 111
Courtesy Musée du Louvre, Paris
Photo: Philippe Chancel, Paris

p. 112
Photo: Himanshu Sarpotdar, Mumbai

p. 114
Photo: Gareth Winters, London

p. 115
Photo: Dave Morgan, London

p. 116
Courtesy MAC, Grand Hornu, Lisson Gallery, and the artist
Photo: Philippe De Gobert

p. 117
Photo: Richard Ashworth / Getty Images

p. 119
Photo: John Riddy, London

pp. 125, 130
Courtesy the City of Chicago and Gladstone Gallery, New York
Photo: Seth Hunter

NICHOLAS BAUME is Chief Curator at the ICA, Boston. Past exhibitions include *About Face: Andy Warhol Portraits* and *Sol LeWitt: Incomplete Open Cubes*, both at the Wadsworth Atheneum Museum of Art, Hartford. There he also curated the *Matrix* exhibition series, including first American museum-organized shows by Francis Alÿs, Sam Durant, Thomas Eggerer, Christian Jankowski, Catherine Sullivan, and Fiona Tan. At the ICA, Baume has curated exhibitions of the work of Kai Althoff, Kader Attia, Carol Bove, Thomas Hirschhorn, and Lucy McKenzie, and the group exhibitions *Getting Emotional* and *Super Vision*, which inaugurated the ICA's award-winning new building by Diller Scofidio + Renfro in December 2006. Forthcoming exhibitions include a survey of the work of Tara Donovan.

MARY JANE JACOB is Professor and Executive Director of Exhibitions at The School of the Art Institute of Chicago. As chief curator of the Museum of Contemporary Art in Chicago and Los Angeles, she staged some of the first U.S. shows of American and European artists such as Magdalena Abakanowicz, Ann Hamilton, Rebecca Horn, Jannis Kounellis, and Christian Boltanski, as well as the first retrospective of Gordon Matta-Clark. Shifting her workplace from the museum to the street, she has critically engaged the discourse around public space, organizing site- and community-based programs including "Places with a Past" in Charleston, "Culture in Action" in Chicago, and "Conversations at The Castle" in Atlanta. She also serves as curator for the Spoleto Festival USA in Charleston, SC. With the book *Buddha Mind in Contemporary Art*, she furthered her research into the nature of artmaking today. Her forthcoming anthology *Slow: Experience into Art* will deal with the art experience and its relation to pedagogy.

PARTHA MITTER is Professor Emeritus in Art History at the University of Sussex. He has been a Fellow of Clare Hall, Cambridge; Institute for Advanced Study, Princeton; Center for Advanced Study in the Visual Arts, National Gallery of Art, Washington DC; Clark Art Institute, Williamstown, Massachusetts; and Getty Research Institute. He was also Radhakrishnan Memorial Lecturer at All Souls College, Oxford. His books include *Much Maligned Monsters: History of European Reactions to Indian Art* (Clarendon Press, Oxford, 1977); *Art and Nationalism in Colonial India, 1850–1922* (Cambridge University Press, 1994); *Indian Art* (Oxford University Press, 2002); and *The Triumph of Modernism: India's Artists and the Avant-Garde, 1922–1947* (Reaktion Books, 2007). He has been an adviser to the Guggenheim Museum and is at present curating an exhibition in the United States of modern Indian artists.

INSTITUTE OF CONTEMPORARY ART / BOSTON